The Naseby Cup

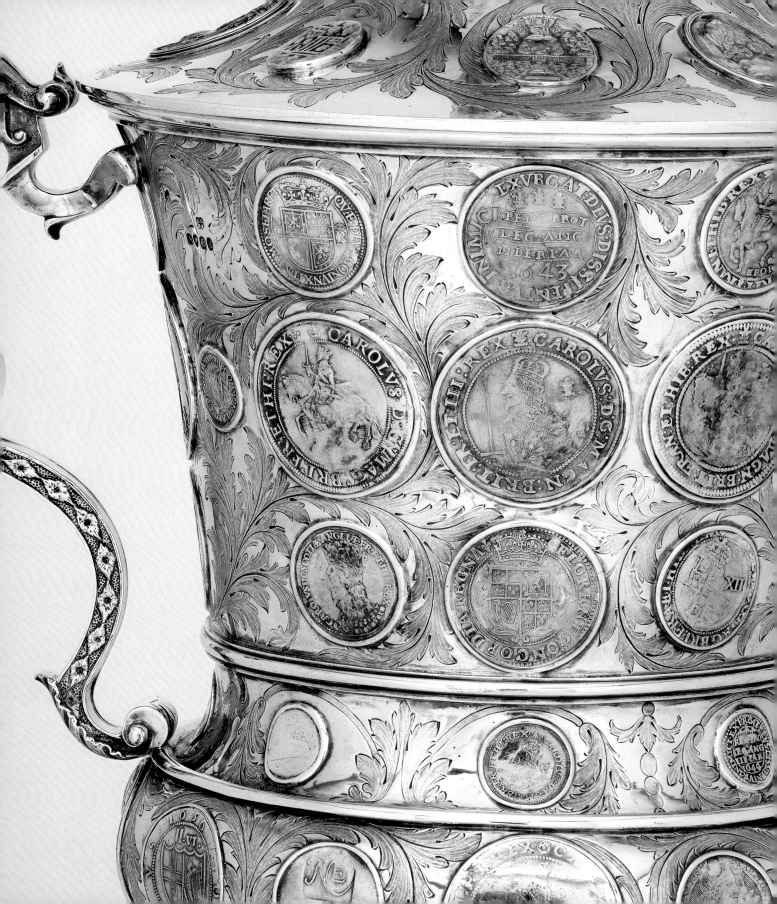

The Naseby Cup

COINS AND MEDALS OF THE ENGLISH CIVIL WAR

Benjamin D. R. Hellings

YALE UNIVERSITY ART GALLERY · NEW HAVEN

DISTRIBUTED BY YALE UNIVERSITY PRESS · NEW HAVEN AND LONDON

YALE COLLECTIONS

Publication made possible by the Andrew W. Mellon Foundation and Mary Cushing Fosburgh and James Whitney Fosburgh, B.A. 1933, M.A. 1935, Publication Fund.

First published in 2024 by the
Yale University Art Gallery
1111 Chapel Street
P.O. Box 208271
New Haven, CT 06520-8271
artgallery.yale.edu/publications

and distributed by
Yale University Press
302 Temple Street
P.O. Box 209040
New Haven, CT 06520-9040
yalebooks.com/art

Produced by the Yale University Art Gallery
Tiffany Sprague, Director of Publications and Editorial Services
Mary Ellen Wilson, Assistant Editor
Grace Zhou, Editorial and Production Assistant
Kathleen Mylen-Coulombe, Rights and Reproductions Coordinator

Project Editor: Stacey A. Wujcik
Designer: Katy Homans
Proofreaders: Livia Tenzer and Eric Zeidler
Mapmaker and illustrator: Adrian Kitzinger

Set in Sabon and Gotham

Printed at Meridian Printing, East Greenwich, R.I.

ISBN 978-0-300-27586-5
Library of Congress Control Number: 2023951033

10 9 8 7 6 5 4 3 2 1

Cover illustration: Detail of the Naseby Cup (p. 10)

Frontispiece: Detail of the Naseby Cup (p. 10); p. 6: Detail of fig. 2.8; p. 56: Detail of the Naseby Cup (p. 10); p. 134: Reverse of the Naseby Cup (p. 10); p. 141: Box for the Naseby Cup (p. 10)

Contents

Director's Foreword

Stephanie Wiles
The Henry J. Heinz II Director
Yale University Art Gallery

Small, seemingly commonplace, and sometimes difficult to appreciate, coins and medals are often overlooked by museum visitors, who may instead be drawn to more familiar objects such as paintings and sculptures. Yet numismatic pieces are like miniature historical monuments; they uniquely reflect the artistic, economic, political, religious, and social aspects of a particular period of human history. With seventy-two coins, medals, badges, and counters from the English Civil War era, including a New England shilling dating to 1652, the Naseby Cup is simultaneously a magnificent freestanding work of art and a collection of fascinating individual pieces that reveal the tumultuous history of a specific moment in time.

This rare cup arrived at Yale University in 1992, when it was donated by Eric Streiner. When the University's numismatic collection was transferred from the Yale University Library to the Yale University Art Gallery in 2001, the Naseby Cup came with it, though it remained hidden in storage. It was not until 2017 that the cup—in its original box—was rediscovered at the Gallery by Benjamin D. R. Hellings, the Jackson-Tomasko Associate Curator of Numismatics, and Jane Miller, former Senior Museum Assistant. Ben was soon inspired to research the cup, the English Civil War, and the numismatic history of the period, culminating in this book. Since 2017, the cup has been continuously on view for visitors, highlighted as a prized treasure of the collection.

The Naseby Cup demonstrates the significant value of numismatics in object-based learning, making it an ideal subject for a monograph in the Gallery's new *Yale Collections* series, and we are thrilled to feature it as the series' inaugural release. There are few introductory numismatic books available to readers that are well illustrated, and even fewer that are centered on a single object. Through an in-depth focus on this extraordinary work of art, *The Naseby Cup: Coins and Medals of the English Civil War* offers readers an engaging introduction to the subject of coins and medals and accomplishes the rare feat of being accessible and important for nonspecialists and specialists alike.

The Gallery's wide-ranging numismatic collection—the largest of any such collection at an American university—has benefited over the years from significant gifts. We are especially grateful for the donations and support of Ben Lee Damsky, as well as Susan G. and John W. Jackson, B.A. 1967, and the Liana Foundation, Inc. Their passion for the numismatics field and their transformative gifts have bolstered the Department of Numismatics in numerous ways. The publication also received support from the Andrew W. Mellon Foundation and Mary Cushing Fosburgh and James Whitney Fosburgh, B.A. 1933, M.A. 1935, Publication Fund.

Acknowledgments

Benjamin D. R. Hellings
The Jackson-Tomasko
Associate Curator of Numismatics
Yale University Art Gallery

This book marks a watershed moment for the Department of Numismatics at the Yale University Art Gallery. It is the first dedicated numismatic monograph published by the Gallery, and it showcases, for the very first time, the Naseby Cup. This remarkable work of art—one that any numismatic collection in the world might envy—deserves to be highlighted in this important way, and it has been a pleasure to serve as both collection curator and author of this publication.

I began this project several years ago, shortly after my arrival at the Gallery in 2016, and since then many people have contributed to its evolution. I owe an immense debt of gratitude to Stacey Wujcik, who, as editor, has made this book significantly better in immeasurable ways. I would like to thank Jerome "Jerry" Platt for his assistance with identifying several medals and for reading an early version of the manuscript, as well as Katie Bourgeau for reading the first draft and providing her feedback as a nonspecialist. I would also like to thank Katy Homans, who is responsible for the publication design, and Adrian Kitzinger, who created the map of English Civil War mints and the elegant drawings of the cup.

At the Gallery, I must give credit for the fantastic photography of the cup—which posed a great challenge due to the reflective quality of the silver and the shape of the cup (not to mention the particularly tricky issue of photographing the interior)—to Senior Photographer Richard House. I am especially grateful to Stephanie Wiles, the Henry J. Heinz II Director; Laurence Kanter, Chief Curator and Lionel Goldfrank III Curator of European Art; and Tiffany Sprague, Director of Publications and Editorial Services, for making this book and the *Yale Collections* series possible—and for enduring my incessant badgering regarding the book's creation. Emily Pearce Seigerman, the Ben Lee Damsky Assistant Curator of Numismatics, provided assistance with innumerable tasks, both large and small, without which this endeavor would have taken much longer.

I would also like to thank many other colleagues at the Gallery: Antonia V. Bartoli, Curator of Provenance Research; Andrew Daubar, Director of Exhibitions, and the entire Exhibitions Department; John Stuart Gordon, the Benjamin Attmore Hewitt Curator of American Decorative Arts; John ffrench, Director of Visual Resources; Patricia E. Kane, Friends of American Arts Curator of American Decorative Arts; Jennifer Lu, former Editorial and Production Assistant; Jane Miller, former Senior Museum Assistant in the Department of Modern and Contemporary Art and the Department of Numismatics; Kathleen Mylen-Coulombe, Rights and Reproductions Coordinator; Ellen Rullo, Museum Assistant in the Department of Numismatics; Tamara Schechter, former Assistant Editor; Cathy Silverman, Associate Conservator of Furniture and Objects; Carol Snow, former Deputy Chief Conservator and Alan J. Dworsky Senior Conservator of Objects; and Grace Zhou, Editorial and Production Assistant.

I also thank Alan M. Stahl, Curator of Numismatics at the Princeton University Firestone Library, in New Jersey. If I have inadvertently omitted anyone from this list, I hope they know how grateful I am for their assistance or advice. Without the help of all these individuals, in one way or another, this book could not have developed in the way that it did.

On a final note, it is a pleasure to thank Eric Streiner, the generous donor of the Naseby Cup, for selecting Yale University as its permanent home. When the cup entered the University's collection in 1992, the former numismatics curator John P. Burnham described it as one of Yale's prized possessions due to its numismatic, artistic, and historical significance. His words remain true to this day.

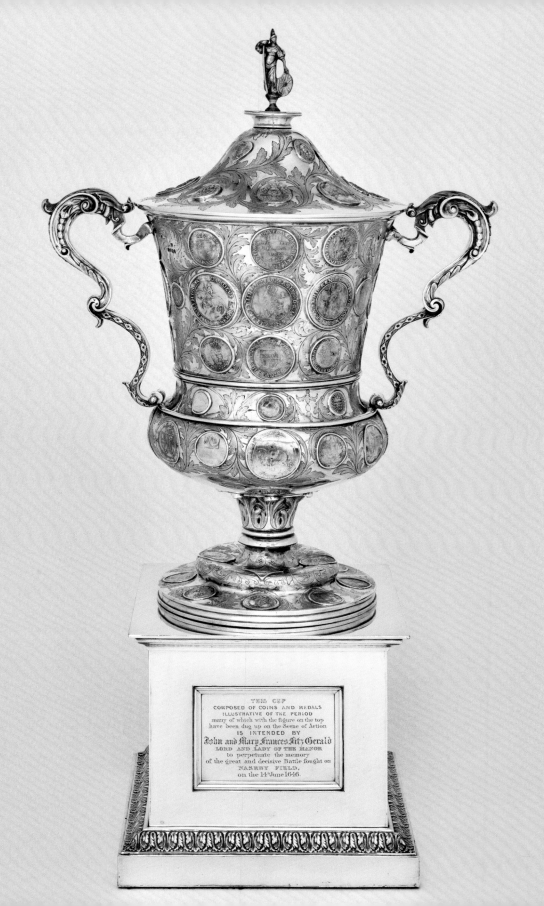

THIS CUP
COMPOSED OF COINS AND MEDALS
ILLUSTRATIVE OF THE PERIOD
many of which with the figure on the top
have been dug up on the Scene of Action
IS INTENDED BY
John and Mary Frances Fitz Gerald
LORD AND LADY OF THE MANOR
to perpetuate the memory
of the great and decisive Battle fought on
NASEBY FIELD,
on the 14th June 1646.

CHAPTER 1

The Creation of the Naseby Cup

The silver Naseby Cup, produced in 1839, is one of the most exceptional numismatic objects in any public or private collection. Standing over two feet tall and featuring seventy-two coins, medals, badges, and counters from the English Civil War period—some of them extremely rare—the cup is an extraordinary example of craftsmanship and provides a unique opportunity to study the historical events of that time through its numismatic pieces.

Elaborate ornamental silverworks, from cups and plates to trophy-like objects, became increasingly popular in England in the early nineteenth century. Many of these objects served as a reward for or celebration of service, in such various fields as business, culture, the military, philanthropy, and politics. Others, however, commemorated civic or political victories ranging from sporting events to moments of historic or national significance. The Naseby Cup, made to commemorate the Battle of Naseby, in Northamptonshire, England, falls into this latter category.

Fought on June 14, 1645, the Battle of Naseby was the climax and decisive confrontation of the First English Civil War (1642–46). At Naseby, the military forces of the English Parliament, led by Oliver Cromwell and Sir Thomas Fairfax, defeated the Royalist army of King Charles I (r. 1625–49), ultimately leading to Charles's loss of the war a year later. Two more wars followed in quick succession, the three now collectively known as the English Civil War. As we will see in the next chapter, this was a turbulent time—a clash of economic, political, religious, and social philosophies, leavened by a desire for power—that affected nearly every aspect of English, Irish, and Scottish life. Together, the wars resulted in the execution of a sitting monarch (Charles I), the establishment of a Commonwealth, the creation of the Protectorate (under Lord Protector Cromwell and then his son, Richard), the establishment of a second Commonwealth, and finally, in 1660, the Restoration: the return of the monarchy.

Interpretations of the Battle of Naseby have changed several times since it was fought. Initially, under the Commonwealth and Protectorate, Naseby was regarded as a great victory and as the beginning of the end of what many perceived as the monarchy's unjust tyranny. Yet, as support for the monarchy rallied with the Restoration, the Battle of Naseby and the Civil War came to be seen as a major, unwanted disruption to the "natural" way of government. By the nineteenth century, as conflict between the lower-to-middle classes and the wealthy elite heightened, Naseby was regarded as a powder-keg issue that revived attitudes toward the war and monarchy on both sides.[1] This revival was driven by political and societal changes within the United Kingdom, as well as the growth of the British Empire.

As Britain's global power expanded, its citizens became increasingly interested in contextualizing national history as a way to understand the country's

The Naseby Cup, London, 1839. Designed by Charles Reily and George Storer. Silver and gold, 26⅜ × 14⅜ × 7⅝ in. (67 × 36.5 × 19.4 cm). Yale University Art Gallery, Transfer from the Yale University Library, Numismatic Collection, 2001, Gift of Eric Streiner, 2001.87.56180

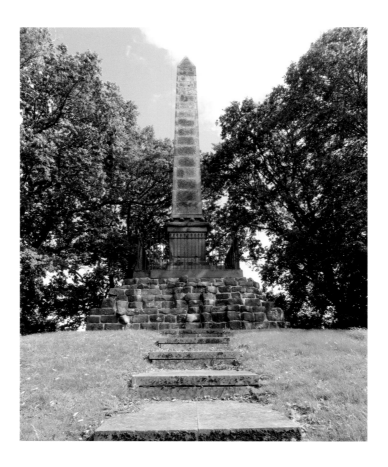

contemporary position in the world. Rewriting and reinterpreting history were
part of the process of creating a national narrative, a process that included the
commissioning of public and private works of art as a means to celebrate the
nation's status as a world empire.[2] Some wealthy individuals and families built
war monuments, occasionally at significant historical sites.[3] In 1823 John and
Mary Frances Fitzgerald—who would later commission the Naseby Cup—
erected an obelisk at the high point of the Naseby parish (fig. 1.1), commemo-
rating the battle at the place where villagers would have watched it from a safe
distance.[4] The plaque on the obelisk reads:

> To commemorate that great and decisive battle fought in this field. On the XIV
> day of June MDCXLV, between the Royalist Army commanded by his majesty
> King Charles the First, and the Parliament forces headed by the generals Fairfax
> and Cromwell, which terminated fatally for the Royalist cause, led to the sub-
> version of the throne, the altar, and the constitution, and for years plunged this
> nation into the horrors of anarchy and civil war: leaving a useful lesson to British
> kings: never to exceed the bounds of their just prerogative, and to British sub-
> jects. Never to swerve from the allegiance due to their legitimate monarch.

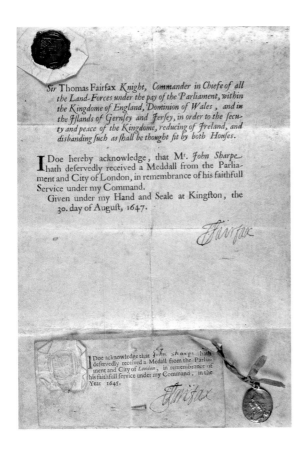

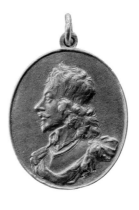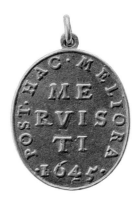

Fig. 1.2

Original award document for a *Medal of Sir Thomas Fairfax* issued to John Sharpe in 1647, with what appears to be the original ribbon. British Museum, London, 2005,0309.1

Fig. 1.3

Thomas Simon, *Medal of Sir Thomas Fairfax*, 1645. Gold, 25 × 21 mm. British Museum, London, M.9055. M.I.i. 318/151, Platt and Platt type B

In addition to creating new monuments to the war, people sought to uncover treasures and artifacts of national significance in the land itself. Some of these objects had already been collected and had remained local, cherished as family heirlooms. Since the immediate aftermath of the Battle of Naseby, farmers and laborers gathered artifacts, including coins and medals, from the battlefield as they worked the land. Over time, as the elite living nearby developed antiquarian interests, they sometimes purchased artifacts from local workers. Amassing such objects, either out of curiosity or for antiquarian research, became increasingly significant as the elite competed to form large and prominent collections.[5] It was the wealthy landowners' view of the battle and Civil War that would shape historical studies from the Restoration until the nineteenth century.

Most materials collected from the battlefield have no recorded archaeological provenance, so only a few items can be connected with certainty to the Battle of Naseby.[6] One medal of Sir Thomas Fairfax has survived with its original award document (fig. 1.2) and is now in the British Museum, in London. The obverse of this Fairfax medal type shows a profile of Fairfax (fig. 1.3), who together with Cromwell led the Parliamentarian forces to victory at Naseby.

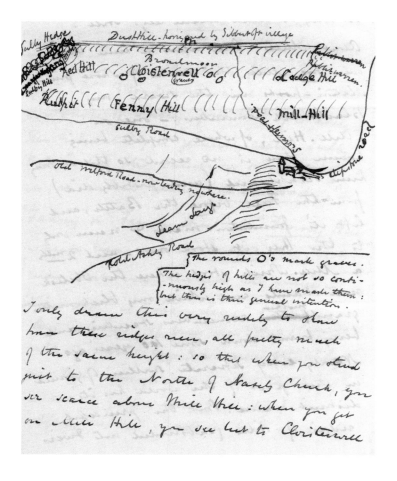

Fig. 1.4

Edward Fitzgerald, letter to Thomas Carlyle
with a sketch of Naseby battlefield, ca. 1842–46.
Cambridge University Library, MS Add.7062/14

On the reverse are the inscriptions "POST · HAC · MELIORA" (Better hereafter)
and "ME / RVIS / TI / 1645" (Thou hast merited 1645). Made by Thomas Simon,
the medal was issued as a military reward following the Battle of Naseby.[7] One
example of the medal, allegedly found on the battlefield, was in the possession
of Rev. Thomas James, the vicar of Sibbertoft and Theddingworth; by 1894
it was owned by his nephew Stewart Sutherland of Theddingworth. Its prove-
nance trail then seems to have been lost.[8] There are two types of the medal, one
of which was made in both gold and silver.[9] All of the known gold examples
are now in institutional collections—one of them could be the medal formerly
in the possession of Rev. James, from the battlefield.

Edward Fitzgerald, son of John and Mary Frances Fitzgerald, was a profi-
cient and indeed highly significant investigator of the Naseby battlefield. In
his twenties, Edward had a keen interest in the battle, and, beginning in 1830,
he spent more than a decade studying it. He gathered information from locals
and sketched views of the battlefield and countryside (fig. 1.4) while collecting
landscape documents related to its history. He was even able to ascertain that

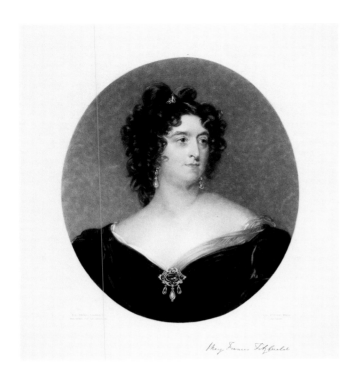

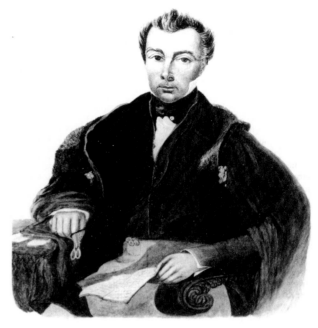

most of the cannonballs found on the field were shot by the Parliamentarian artillery, based on their findspots. In 1842 Edward began an amateur excavation campaign. Unfortunately, most of his research findings were ignored or misinterpreted by contemporary historians, and they were not taken up by others until the end of the nineteenth century and the early twentieth century.[10] Some of his archaeological numismatic finds, however, may have been incorporated into the Naseby Cup.

John and Mary Frances Fitzgerald

Mary Frances Fitzgerald (1779–1855; fig. 1.5) was heiress to one of the largest fortunes in Britain. The Fitzgeralds had originated from an ancient Irish family and consolidated their vast wealth through generations of intermarriage. In 1801 Mary married John Purcell (1775–1852; fig. 1.6), her first cousin. Although the Purcells were also of high standing and were well connected as descendants of the Barons of Loughmoe, Ireland, the two families were not equal. John's pride lay in the fact that his mother had been a Fitzgerald, and this presumably was a motivation to marry his cousin to reinforce the connection. Mary had a domineering personality and did not think highly of John, but she followed the example set by her parents, who had also been first cousins and had married within the family to protect their wealth.[11] John later assumed the Fitzgerald name after the death of his father-in-law, even though he was not legally

required to do so in order to access the Fitzgerald fortune. In 1810 the couple inherited the three-thousand-acre manor of Naseby Wooleys, one of several manors at Naseby.[12]

Mary was an avid supporter of the arts and was fascinated by the traditions of the Fitzgerald family. She considered herself a great beauty, and Sir Thomas Lawrence, one of the leading British portrait artists, was commissioned to paint her no fewer than twenty-four times. Unsatisfied with life in the country at Naseby Wooleys and the ennui of being married to a man she perceived as dull, Mary spent considerable time away from her husband and their eight children. She traveled around Europe or spent time in London, where many of her intimates were not always from social circles designated by birth and wealth but rather were painters, poets, musicians, architects, and even leading actors.[13]

John was a large man who nevertheless seemed perpetually dwarfed by his wife's presence, according to Edward. He was described as amiable but incurably absent-minded and no match for his imperious wife. Never one to take anything seriously, John adopted the congenial life of a country gentleman at Naseby Wooleys. However, the mismatched marriage, particularly in regard to wealth, left him unhappy. On account of his gullibility and lack of business acumen, Mary and her trustees were unwilling to turn the couple's money over to his management, as tradition would have dictated; time and again, he tried to prove their error but inevitably justified their decision.[14]

While it is uncertain whether Mary liked or disliked the manor she had inherited, the family did demonstrate an affiliation with the Battle of Naseby. The Fitzgeralds claimed Oliver Cromwell as a family ancestor (although the truth and basis of that claim are unclear). At Naseby Wooleys, a wooden figure with what was then thought to be Cromwell's armor was displayed in the hallway, and his gold watch was kept in the house. This family lore, together with Mary's love of extravagance and support for the arts, led to the Fitzgeralds' commission of the Naseby Obelisk and later the Naseby Cup.[15]

The Making of the Naseby Cup

The cup was produced in 1839, sixteen years after the erection of the obelisk and after several years of Edward's study of the battlefield. The silver hallmark stamps on the cup's exterior (fig. 1.7) reveal some details of its creation. The lion passant guardant mark at the far left indicates that the cup is .925 sterling silver, and the leopard's head stamp indicates that it was produced in London. The letter *D* denotes the date, 1839. At the far right, the sovereign's head stamp (Queen Victoria) specifies that duty was paid on the cup. The initials of the silversmiths, Charles Reily and George Storer, appear as well, marking their workmanship.

Fig. 1.7

Silver hallmark stamps on the exterior of the Naseby Cup

16

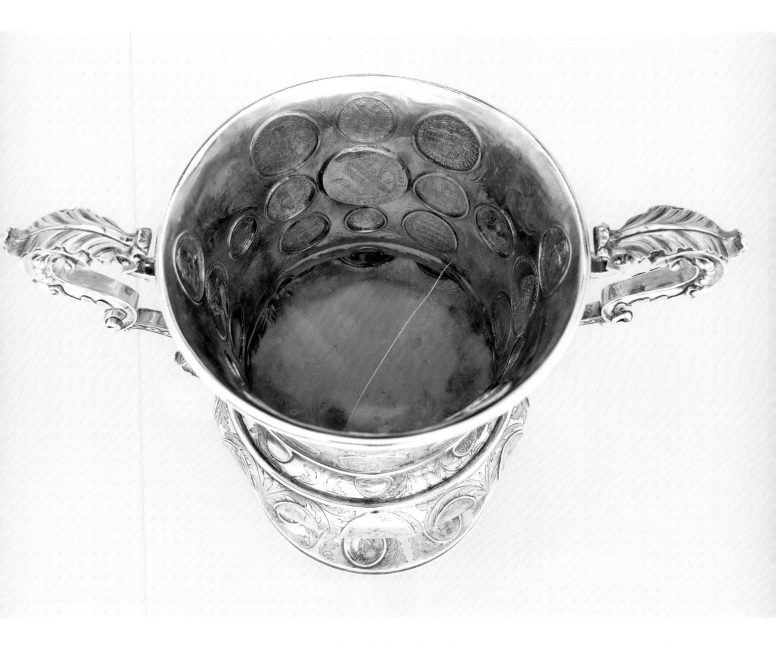

Fig. 1.8

Interior of the cup

The cup has a high number of numismatic pieces—seventy-two in total—many of which, such as the New England shilling (see cat. 58), are extremely rare. While some other Victorian-era decorative silver objects feature numismatic pieces, they tend to have only a single or a few coins or medals, melded to the exterior of the object, thus obscuring one side of the pieces. The Naseby Cup, however, was smithed in a manner that allows one to view both sides of each numismatic piece—one side on the exterior of the cup and the other on the interior (fig. 1.8). The creation of the cup was therefore an incredibly labor-intensive

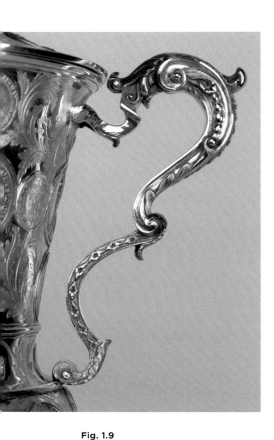

Fig. 1.9

One handle of the cup

process. To begin, the silversmiths would have heated a sheet of silver to hammer it into the shape desired for the body and lid. As it was hammered and forged, the silver continually hardened and needed to be reheated, in a process known as annealing, to keep it malleable enough to allow the silversmiths to work. When the body and lid of the cup were complete, the decorative foliage was added with steel punches and a chasing hammer.

The process for integrating the coins, medals, badges, and counters into the cup required additional careful steps. After the cup was smithed, Reily and Storer made a hole for each numismatic object. To ensure that the objects would fit and stay in place, a small bezel-like frame was created for each one; the object, placed in its frame, was then inserted into the hole. The addition of the frame enabled the smiths to have a good grip for soldering the object into the cup (see cat. 42). It also gave them flexibility in placing the objects, as they could adjust the thickness of the frames to accommodate the curvature of the vessel (see cat. 50). The objects themselves would also have required considerable work. Presumably, each one would have been heated and shaped to fit the contour of the cup before being inserted into its frame (see cat. 44). Once the objects were soldered into place, they were polished, along with the cup's silver surface. This polishing—a common practice among decorative arts and silver collectors but contrary to numismatic convention—unfortunately has destroyed the natural patina of the numismatic objects, resulting in some discoloration.

The handles were added as the final step, and although they were partly made from molds and were only semicustomized, they were also labor intensive. Each handle (fig. 1.9) has three parts: a bottom segment, a top segment, and a U-shaped prong at the top. The bottom segment is visibly thinner than the top one. This was a deliberate decision: a thicker bottom segment would have visually detracted from the cup as it joined the body. Reily and Storer used cast molds of handles from other vessels to create the two segments and then connected them midway. This is visible not only in the different thicknesses of the top and bottom segments but also in the different decorative patterns on both; while the top has foliage on all its visible sides, the bottom has a lozenge pattern on only two sides. A scroll detail appears where the two segments meet and where the bottom of the handle meets the cup. Rather than connecting the top of the handle directly to the cup, which would have interfered with the lid, Reily and Storer added the U-shaped prong, angled to connect to the vessel. The cleverly designed shape allowed for the handles to be carefully placed around the coins that are just beneath them (see cats. 16 and 20).

The silver pedestal (figs. 1.10–.11) was made as a separate piece that detaches from the cup. On the front is an inscription that names the commissioners, John and Mary Frances Fitzgerald, and explains that the cup was intended to commemorate the Battle of Naseby:

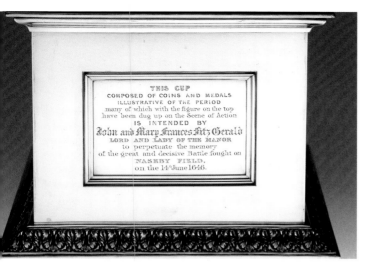

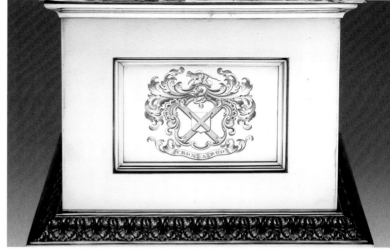

Fig. 1.10

Front of the pedestal, with an inscription commemorating the Battle of Naseby

Fig. 1.11

Reverse of the pedestal, with the Fitzgerald family crest

THIS CUP

COMPOSED OF COINS AND MEDALS

ILLUSTRATIVE OF THE PERIOD

many of which with the figure on the top

have been dug up on the Scene of Action

IS INTENDED BY

John and Mary Frances FitzGerald

LORD AND LADY OF THE MANOR

to perpetuate the memory

of the great and decisive Battle fought on

NASEBY FIELD,

on the 14th June 1646.

Curiously, the inscription has an incorrect date for the Battle of Naseby—the year is recorded as 1646, not 1645. This may have been a consequence of changes to the calendar. From 1155 to 1752, England followed the Julian calendar, and the legal year began on Lady Day, March 25. When Britain adopted the Gregorian calendar in 1752, the first day of the year shifted to January 1. As a result, some historical events were documented in two different years. For example, before 1752, Charles I's execution on January 30 was recorded as having occurred in 1648; after the calendar change, it was recorded as having occurred in 1649. To further complicate matters, with the switch from the Julian to the Gregorian calendar, the calendar year was shortened by eleven days. As can be expected, these changes did not go smoothly, and there is evidence of emotional resistance to them, as people continued to celebrate holidays on days that followed "old style" Julian dates well into the nineteenth century.[16]

Yet the shift from the Julian to the Gregorian calendar does not properly account for the use of the year 1646 on the cup. Both before and after 1752, the year should have been recorded as 1645 (as it was on the obelisk). Interestingly, the battle was incorrectly dated to 1646 in some mid-nineteenth-century literature, including in an issue of *Household Words*, an English weekly journal edited by Charles Dickens in the 1850s, as well as in some contemporary history books.[17] Still, most nineteenth-century publications record the accurate year (1645), so it is not entirely clear what circumstances led to the year 1646 being inscribed on the cup.

Another puzzle in the inscription is the claim that many of the seventy-two numismatic pieces were found on the "Scene of Action." This is difficult to substantiate, since most objects that purportedly were found on the battlefield have poor documentation (with the exception of those found there more recently, in the twentieth and twenty-first centuries). Some of the pieces on the cup look heavily worn and beaten, presumably as a consequence of circulation or of erosion from being buried in the soil for some time, and there are several common low-value coins that certainly seem out of place on such an ornate vessel. Other pieces on the cup are numismatic rarities, and some were struck *after* the battle. The memorial medals for Charles I and Cromwell (see cats. 26, 32, 40, and 54), for instance, were not struck until after their deaths, in 1649 and 1658, respectively. The variety among all the objects—low-value, common, and worn coins alongside prized numismatic rarities—would appear to substantiate the claim that some were dug from the "Scene of Action," possibly by Edward Fitzgerald himself. The decision to include a spectrum of numismatic pieces may also have been an attempt to bolster the impression of the cup's national and historical significance.

We can safely assume that a deliberate decision was made regarding which side of each piece, the obverse or reverse, would be displayed on the cup's exterior. It is not always clear how these decisions were made, although some objects were intentionally paired. On the lid (fig. 1.12), for example, a heart-shaped locket of King Charles II (r. 1660–85) and his wife, Queen Catherine of Braganza, Portugal, was sliced in half, so that both sides of the locket could be displayed across from one another (see cats. 1 and 3). Another example is the pairing of two "Funeral" and Memorial Medals of Cromwell (see cats. 26 and 32), which appear under the handles of the cup. One of the medals is set to display the obverse on the cup's exterior, and the other, the reverse—thus, the viewer can see both sides without having to look inside the cup.

On the back of the pedestal (see fig. 1.11), the Fitzgerald family lineage is acknowledged with an engraving of the family crest with the family motto or ancient war cry, "CROM A BOO." The motto *Crom Abu*, meaning "Crom Forever" in Irish, comes from one of the Fitzgeralds' ancestral homes, the Castle of Crom in the town of Croom, County Limerick. Ireland was one of the first countries

Fig. 1.12

Lid of the cup, with one half of a heart-shaped locket of King Charles II placed across from the other half, depicting Queen Catherine of Braganza (cats. 1 and 3)

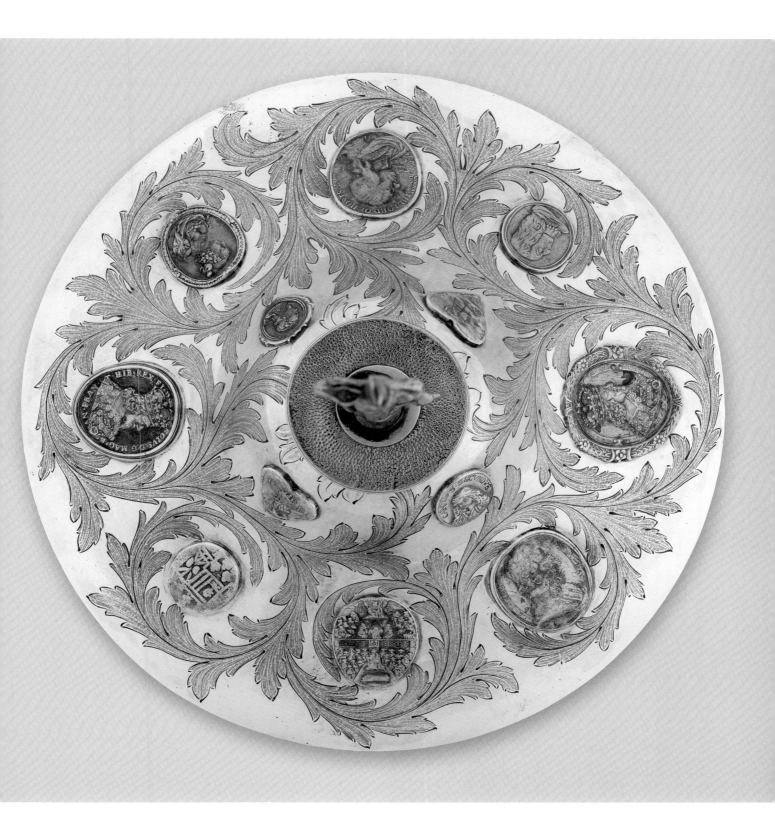

to develop a system of hereditary surnames, in about the eleventh century. As a family grew and split, new crests were devised and modified. The crest on the Naseby Cup is relatively new and came from Mary Frances Fitzgerald's father, John Fitzgerald. At the center is an inescutcheon (a small shield, or escutcheon, within a larger shield) bearing a Saltire (the cross of Saint Andrew). The crescent engraved above the inescutcheon is a cadency mark, a symbol applied to a coat of arms to distinguish between various branches, or cadets, within a family. The crescent here relates to John (Purcell), after he assumed the Fitzgerald family name and became the second eldest "son" of the family lineage (after Mary's brother, who died at a relatively young age). The heavily stylized helmet at the top denotes John's rank as an esquire.[18] Above the helmet is a monkey on all fours. This curious inclusion derives from the legend that, as a baby, John FitzGerald, first Earl of Kildare (ca. 1250–1316), was saved from a fire in Woodstock Castle, in Athy, County Kildare, by a pet monkey. The heroic animal appears on many Fitzgerald crests. The torses at the sides of the inescutcheon reference the historical use of crests, which originally were carved in light wood or pressed into boiled leather using a mold, then fastened to a helmet by a torse, or wreath, that consisted of two pieces of silk twisted together. The colors of the torses would always have matched the principal color and metal of the arms; in this case, they would have been red and white or silver, like the traditional Saltire.[19]

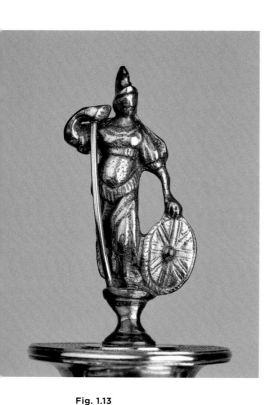

Fig. 1.13

The Britannia figure atop the lid of the cup

The lid of the Naseby Cup is topped by a small, unrefined Britannia figure (fig. 1.13). Juxtaposed with the ornate silver vessel, this figure may initially seem out of place. Yet its inclusion is justified, since it was in fact recovered from the Naseby battlefield. The figure, which has lost its original trident, appears to have originally been part of some other object (or possibly it was a standalone object), and it has an uneven molded base on which it stands. The silversmiths Reily and Storer reworked this base, as evidenced by the angle at which it was added to the cup, and then screwed it into the lid. Despite the simple nature of the Britannia figure, the presence of another type of artifact from the battlefield would have added a level of sophistication to the cup as the Fitzgeralds competed with nearby elite in showcasing the historical significance of their collection.

This figure would have served another useful purpose. Britannia first appeared in Classical antiquity to refer to the British Isles and the Roman province(s) there. Later, during the reign of Elizabeth I (r. 1558–1603), the usage of the Britannia figure was revived in art, but it gained real traction upon her death and the succession of James I (r. 1603–25), who brought the Kingdoms of England (and the dominion of Wales), Ireland, and Scotland together under his rule. His successor, Charles I, used "Britannia" in his title, and it is well documented on his coins, where it is shortened to "BRIT." After the Restoration, the Britannia figure made its first appearance on English coins, on a circulating farthing of 1672. Given this history, the Britannia

figure atop the Naseby Cup—in addition to being an unusual curio from the battle—would have been both a potent reminder of the transformative period of the seventeenth-century English Civil War and a symbol of contemporary nineteenth-century Britain as it expanded its empire across the world.

The careful design and masterful work that went into the creation of the Naseby Cup demonstrate the significance of its commission. The Battle of Naseby was a pivotal moment in British history, one that, as we will see in the next chapter, changed the course of the English Civil War and the political, religious, and social events in the decades that followed. Naseby has always been considered a watershed moment in English history. By capitalizing on this history—first, through the construction of a monumental obelisk that towers over the landscape, and then, through the commission of the cup—the Fitzgeralds conspicuously displayed their power and wealth and ensured that they would leave their mark in the public eye.

The cup and its numismatic pieces have survived in remarkably good condition, thanks in part to the box that was originally made for the work, which survives to this day (see p. 141). Although the box is damaged and the key to its lock has been lost, one can well imagine that it protected the cup when Mary Frances Fitzgerald traveled with it to London, where she is known to have hosted splendid dinners in Portland Place with gold plate and decorations, or on one of her trips abroad.[20] Then as now, the Naseby Cup certainly would have impressed viewers, as both an artistic masterpiece and a commemoration of a critical period of British history.

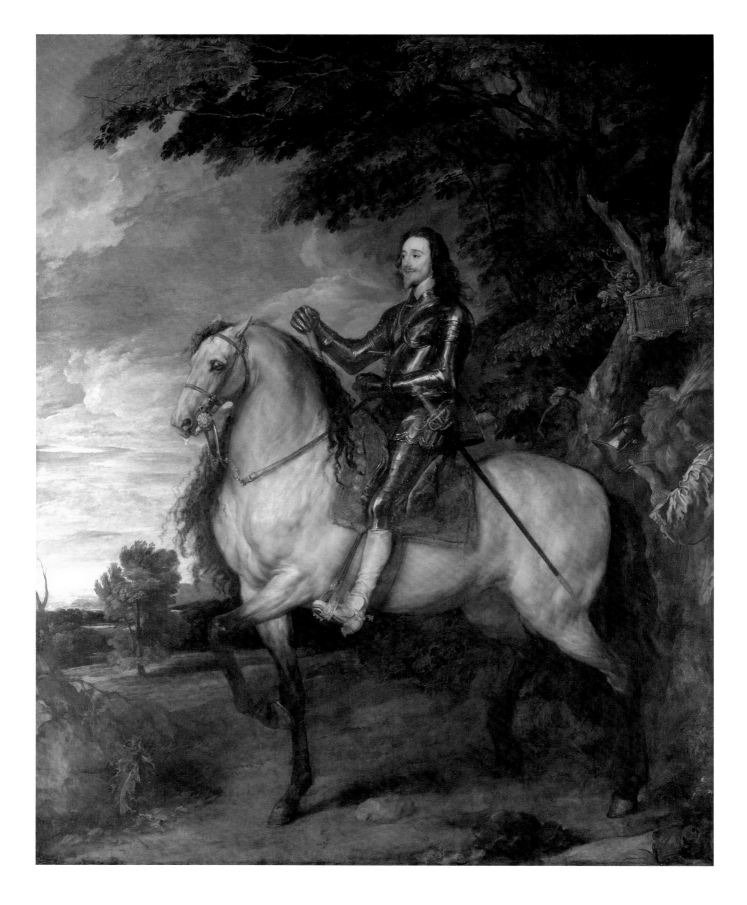

A History of the English Civil War

Though the Naseby Cup was made in 1839, almost all of the coins, medals, badges, and counters on it date to the English Civil War period of the mid-seventeenth century. Most include images of figures and references to events from the era. A full appreciation of the cup, and the intricate numismatic iconography it displays, thus requires an understanding of the events of the war.

The English Civil War was, in fact, a series of three wars fought in the British Isles between 1642 and 1651 over issues of political governance and religious freedom.[1] The First English Civil War (1642–46) began when members of Parliament and its supporters (the Parliamentarians) opposed King Charles I and his supporters (the Royalists) over the governance of the Three Kingdoms of England, Ireland, and Scotland. After this war ended with Charles's capture and imprisonment, two more wars followed in quick succession. The Second English Civil War (1648–49) erupted after Royalists freed Charles from captivity, with the intent to restore him to the throne, but it quickly ended with Charles's defeat and execution. The Third English Civil War (1649–51) partly grew out of a conflict that had begun in 1641 between the Irish Confederates, who had sided with the English Royalists, and the Parliamentarians, then under the leadership of Oliver Cromwell. At the same time, another war was taking place in Scotland, where Charles II, son of the executed king, had successfully united the Scottish Army of the Covenant with Royalist supporters to fight the Parliamentarians. Charles II and his forces were defeated at the historic Battle of Dunbar on September 3, 1650, and the third war ended on September 3, 1651, resulting in the establishment of the Commonwealth. Shortly thereafter, the Protectorate was established, with Cromwell as Lord Protector, but this was short-lived; in 1660 Charles II was named king and the monarchy was restored.

Clearly, this was a complicated and tumultuous time. The Civil War had lasting repercussions in economic, political, religious, and social life throughout Britain. This chapter, which serves as an overview of these events, aims to situate the Naseby Cup and its components—as well as seventeenth-century developments in numismatic production, as discussed in the next chapter—within the historical context of the English Civil War.

The First English Civil War, 1642–46

Political and Religious Setting

Most of the numismatic objects on the Naseby Cup pertain to the First Civil War, the roots of which can be traced as far back as the sixteenth century and the reign of King Henry VIII (r. 1509–47). At that time, the Protestant Reformation was reshaping religious life throughout Europe by challenging the authority of the Roman Catholic Church. The most famous incident of the English Reformation related to Henry's desire for a male heir. When his wife Queen

Anthony van Dyck, *Equestrian Portrait of Charles I*, ca. 1638–39. Oil on canvas, 12 ft. ½ in. × 9 ft. 7 in. (367 × 292.1 cm). National Gallery, London, NG1172

Catherine of Aragon did not give birth to a son, Henry sought to annul the marriage so he could marry Anne Boleyn (a Protestant). The pope refused to grant the annulment, so Henry established the Church of England by forcing the passage of the Act of Supremacy of 1534, which named him "Supreme Head" of the Church, and he married Boleyn. Queen Elizabeth I finalized this process with the Act of Supremacy of 1558, which named the monarch "the Supreme Governor of England in all matters, spiritual or temporal." Elizabeth maintained, in a tempered form, many Catholic rituals that would later become distressing to the growing Puritan population in England.

The English Reformation transformed politics and religion in the country. It ultimately strengthened the power of the House of Commons, which Henry had deliberately used to implement his desired policy; it contributed to the formation of a gentry class, through the sale of the property of Catholic monasteries that were dissolved; and it paved the way for the rise of a Puritan movement. A century later, these three factors would play a pivotal role during the reign of Charles I (fig. 2.1; see also p. 24) and contributed to the outbreak of the Civil War.

At the start of Charles's reign, disagreements regarding finances and legislative authority dictated the relationship between the monarch and Parliament.[2] In 1623, shortly before the death of his father, King James I, who was also King James VI of Scotland (r. 1567–1625), Charles was plotting to declare war on Spain.[3] This would require significant financial resources, for which he turned to the House of Commons. The Commons offered only a fraction of the funds Charles needed, and it limited the yearly support he could

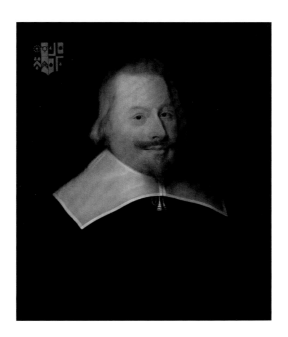

Fig. 2.2

By or after Edward Bower, *John Pym*, ca. 1640. Oil on canvas, 24⅝ × 20½ in. (62.6 × 52 cm). National Portrait Gallery, London, Given by Paul Gore, 2003, NPG 6650

rely on through taxation.[4] In response, Charles imposed new taxes, which not only were unpopular with the people but also represented a direct confrontation with Parliament regarding the right to control the collection of taxes.[5] This fueled debate about whether the monarch derived the right to rule from Parliament or from the divine.

Religious disputes intensified during the early years of Charles's reign. In 1625 the king married Henrietta Maria, younger sister of King Louis XIII of France (r. 1610–43). Henrietta Maria was a Roman Catholic, and as part of the marriage agreement, Charles committed to granting toleration to English Catholics who did not attend services at the Church of England. Although he took his position as Supreme Governor of the Church of England seriously, his marriage amplified fear among Puritans that he wished for a return to Catholicism. This was perceived by many, especially by the ever more powerful members of Parliament—most notably John Pym (fig. 2.2)—as a loss of English liberty.

The discord between Charles and members of Parliament continued to plague their relationship. Frustrated, Charles dismissed Parliament in 1629, in an attempt to rule without it. From early 1639 on, he increasingly sought foreign aid against his domestic adversaries.[6] Nevertheless, he was forced to reconvene Parliament after he was left bankrupt following his defeat by the Scottish Covenanters (the political and religious group that upheld the Scottish Presbyterian Church) in the Bishops' Wars of 1639 to 1640. Thus, on November 3, 1640, Charles reconvened Parliament; this is now known as the Long Parliament, because it was not dissolved until 1660.[7] Although it had been assembled to

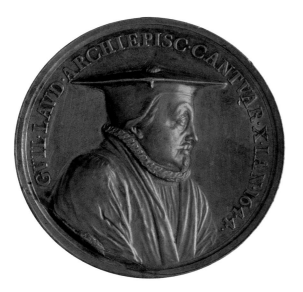
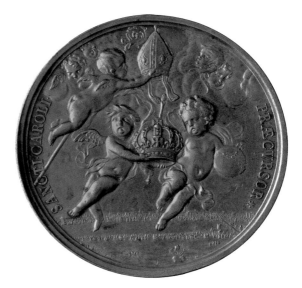

Fig. 2.3

John Roettiers, *Medal Commemorating the Execution of Archbishop William Laud*, London, 1644–45. Silver, 83.07 g, 12:00, 58 mm. Yale University Art Gallery, The Susan G. and John W. Jackson, B.A. 1967, Numismatics Acquisition Endowment Fund, 2023.10.5

regulate the governance of the country and pass financial bills, this reconvening of Parliament ultimately led to the outbreak of the Civil War.

The Long Parliament included a new member of modest means, Oliver Cromwell, who would make his name in the ensuing decade of turmoil and conflict. When Cromwell, Pym, and the other members of Parliament met in 1640, they could not attack the king directly, as it would amount to treason; instead, they began impeachment proceedings against two of Charles's most loyal subordinates: Thomas Wentworth, Earl of Strafford, and Archbishop William Laud (fig. 2.3). Pym, the leader of the Long Parliament, argued that the two men supported the king's alleged plans to reinstate Roman Catholicism, and they were convicted and publicly executed. The bishops who were members of the House of Lords were also impeached and imprisoned. Henrietta Maria responded by asking her confessor to seek financial assistance from the Vatican, reinforcing Puritan fears of the monarch's papal allegiance. Pym successfully amassed a large following, inciting fear of a "papist conspiracy," while Charles's sense of entitlement and belief that he was answerable only to God played into Pym's narrative. As the scholar Anthony Fletcher has written, "What men saw was the king's aloofness, his rigidity, . . . his French wife. . . . What they suspected, quite correctly, was his deviousness and taste for intrigue."[8]

In addition to reconvening Parliament, Charles reluctantly agreed on February 16, 1641, to the Triennial Act, which limited his power. The act guaranteed that parliamentary sessions would be held every three years (after the eleven-year hiatus between 1629 and 1640) and stipulated that Charles could only levy certain duties with parliamentary permission.[9] Despite Charles's concessions, many members of Parliament, including Pym, remained convinced that the king would use any opportunity to retract himself from the agreement and reinstate

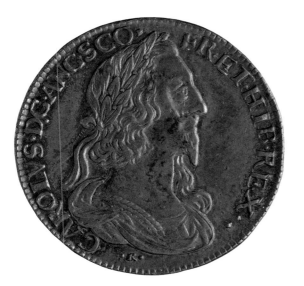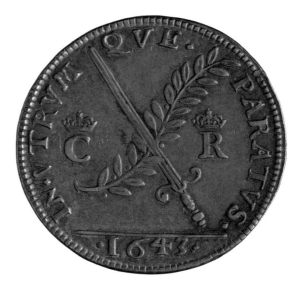

Fig. 2.4

Sir Thomas Rawlins, *Medal of Peace or War*,
London, 1643. Silver, 1.09 g, 12:00, 26 mm. Yale
University Art Gallery, The Susan G. and John W.
Jackson, B.A. 1967, Numismatics Acquisition
Endowment Fund, 2023.10.4

Roman Catholicism.[10] Parliament therefore began to raise its own army through voluntary enlistments. On November 22, 1641, in response to Charles's appointment of two of the previously impeached bishops as King's Councillors, the Commons published the "Grand Remonstrance"—a list detailing Parliament's grievances against the king and a proposal for the power to veto his appointments. Parliament's proposal of the Militia Bill on December 7, which would give Parliament the sole authority to appoint army and navy officers and to name the commander (a "Lord General"), provoked Charles to take a strong stand. From January 4 to 5, 1642, he attempted to arrest five parliamentary leaders, including Pym. When Parliament refused to hand them over, Charles personally went to Westminster to effect the arrests, in vain. On March 3, he departed Whitehall Palace for northern England. He later wrote, "Some affirmed that I meditated a war when I went from Whitehall only to redeem my person and my conscience from violence. God knows that I did not then think of a war."[11]

Indeed, it appears that Charles had not wanted the dispute with Parliament to escalate to a full-scale war (although, by the outbreak of the war, Henrietta Maria had already taken the crown jewels and sailed to Holland to purchase weapons and seek support).[12] Nevertheless, while Parliament continued to make demands, Charles began to amass soldiers and supplies, as the two groups "became the prisoners of competing myths that fed on one another, so that events seemed to confirm two opposing interpretations of the political crisis that were both originally misconceived and erroneous."[13] On August 2, 1642, Charles raised his standard at Nottingham, declaring war against Parliament (fig. 2.4).

The Outbreak of War

Both the Royalists and Parliamentarians were confident that the war would be quickly decided through a single battle. Neither side was able to field a proper army, so both concentrated their initial efforts on recruitment.[14] Charles primarily relied on support from the more rural north and west, while Parliament gained support from the more urban and developed southeast, including London. Parliament also controlled the armories, major ports, and naval fleet.[15] The size of each army was modest, counting at most sixty to seventy thousand men. Both sides also struggled to finance the war. Parliament initially borrowed money from London, offering to repay loans with interest. Charles forced the quartering of troops on counties and allowed local commanders to impose levies, further alienating many citizens. He also requested funds from the universities of Cambridge and Oxford, which donated plate to be melted and struck into coin. Each side received help from beyond England, through either trade or the recruitment of soldiers. Notably, Charles benefited from the aid of his nephew, Prince Rupert of the Rhine, an experienced commander in the Thirty Years' War (1618–48).[16]

The first confrontation was the Battle of Edgehill, Warwickshire, on October 23, 1642. Neither side dealt a decisive blow, and both had failed to develop a clear strategy beyond the battle, resulting in minor skirmishes the following year and unproductive negotiations to end the hostilities.[17] Since Charles could see that the war was going to drag on, he established a royal mint at Oxford. England's historic mint in the Tower of London remained active— but it was now minting solely for Parliament.[18]

The campaign season of 1643 was disorganized, with neither side gaining a notable advantage, but over the course of 1644, the direction of the war changed dramatically. Parliament hired a Scottish Covenanter army twenty-thousand strong, intensifying the religious aspect of the war. In three large-scale confrontations, the Royalists lost York and most of northern England but inflicted significant losses on the Parliamentarian forces.[19] Charles had ample opportunity to further weaken his opposition but resisted, demonstrating his cautious and conciliatory attitude. This contrasted starkly with the ruthlessness of Cromwell (now lieutenant general of horse), who was determined to achieve victory by any means.[20]

On both sides, there were signs of fatigue and a loss of enthusiasm for a war many considered senseless. Charles's success in the south caused dissension among Parliamentarian commanders as well as mutiny and desertion among the enlisted. This led to Parliament's creation of a new army with full-time professional soldiers who could fight throughout the country (as opposed to being limited by region), which came to be known as the New Model Army.[21] Led by Sir Thomas Fairfax (fig. 2.5; see also fig. 1.3), the New Model Army would cost £50,000 per month

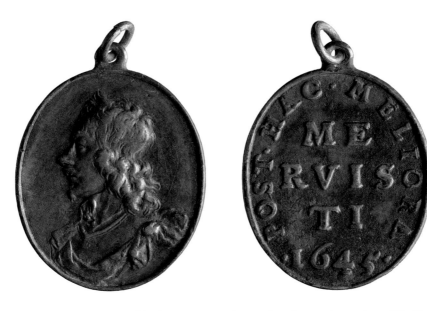

Fig. 2.5

Thomas Simon, *Medal of Sir Thomas Fairfax*,
London, 1645. Silver, 2.75 g, 24 × 20 mm. Yale
University Art Gallery, The Susan G. and
John W. Jackson, B.A. 1967, Numismatics
Acquisition Endowment Fund, 2023.10.7.
M.I.i. 318/151, Platt and Platt type B

and had 22,400 men, increasing the total number of Parliamentarian soldiers to some 100,000 to confront Charles in the spring of 1645.[22]

In late 1644 and early 1645, Charles pursued peace negotiations and even offered to go himself from Oxford to Westminster to discuss a settlement, but Parliament did not accept. By early spring, Cromwell had been given his own command and won several skirmishes near Oxford, resulting in the capture of Royalist munitions and stores. At the end of April, the New Model Army under Fairfax headed toward Oxford, and Charles went north to rejoin Rupert. Fairfax was joined by Cromwell, now lieutenant-general and second-in-command of the New Model Army, and together they tracked the Royalists to Naseby on June 13.[23]

The Battle of Naseby

The Battle of Naseby was the decisive confrontation of the First Civil War. Two sketched maps of the battlefield and regimental deployment—one from each side's perspective—have survived, allowing historians to reconstruct the events with great clarity. The first is the map Sir Bernard de Gomme made for Rupert after the battle (fig. 2.6). The second, more renowned, map is Robert Streeter's, published in 1647 (fig. 2.7).[24] In Streeter's illustration, both armies are represented in profile, though the Royalist army lacks detail.[25] The maps show that the Parliamentarian force consisted of twelve cavalry, one dragoon, and eight infantry regiments, with a total of 13,500 men. The Royalist force was approximately 10,000 men.[26]

On the day of the battle, June 14, 1645, Fairfax hid his forces slightly behind Naseby ridge, making his position unclear to Rupert and the Royalists, after

Fig. 2.6

Sir Bernard de Gomme, *Plan of the Battle of Naseby*, 1645. Ink and watercolor on handmade laid paper, 11⁷⁄₁₆ × 14⁷⁄₈ in. (29 × 37.7 cm). Bodleian Libraries, University of Oxford, MS. Eng. hist. c. 51, fols. 197v–198r

determining that this would suit his less experienced troops (fig. 2.8). Despite having the smaller force, Rupert took the offensive and was able to break through the Parliamentarian line. As the battle turned against the Parliamentarians, Fairfax committed his reserve troops, but it was Cromwell who would lead the Parliamentarians to victory. Charles sent in the Royalist reserves, and in the confusion of the later stages of the battle, prepared himself to charge the left flank with his guards. The Earl of Carnwath grabbed the bridle of Charles's horse, asking, "Will you go upon your death in an instant?" as he turned the horse around.[27] This led the troops to believe that they had been ordered to retreat. Rupert, who had been delayed in unsuccessfully fighting the guards of the Parliamentarian baggage train, rejoined Charles on the battlefield to make a last stand.[28] Unable to inspire the broken and exhausted troops, however, they fled. Cromwell's men chased the retreating Royalist cavalry for nearly twenty miles, while the rest of the Parliamentarian forces captured the Royalist baggage train.

For the Royalists, the battle's most significant outcome was not the loss of men. In fact, given the impact the battle would have on the course of the war, a relatively small number were killed in action.[29] The real disaster was that about five thousand troops and the whole of their artillery train had been captured, and eight thousand arms had been lost. Further damaging the Royalist cause was the

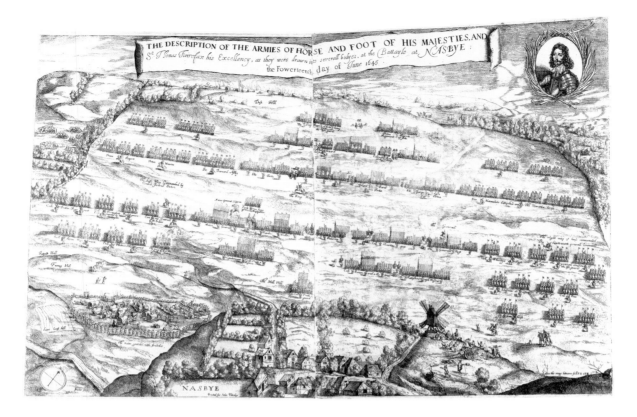

Fig. 2.7

Robert Streeter, *The Description of the Armies of Horse and Foot of His Majesties, and Sir Thomas Fairefax his Excellency, as they were drawn into severall bodyes, at the Battayle at Nasbye: the Fowerteenth day of June 1645*, from Joshua Sprigge, *Anglia Rediviva* (London: John Partridge, 1647). Engraving. National Army Museum, London, NAM.1977-04-44-1

loss of a cabinet containing Charles's private papers, including drafts and copies of letters to his wife in France that offered the Parliamentarians an important propaganda advantage.[30] Altogether, the Battle of Naseby—the first triumph of the New Model Army—was a turning point for the Parliamentarian cause.

The End of the First Civil War

Despite the defeat at Naseby, Charles remained confident. He believed his hold over western England was secure. In Scotland, which had been in conflict since the Bishops' Wars, James Graham, Marquis of Montrose, had secured Royalist victories. In addition, Charles had started attempting to recruit reinforcements from (largely pro-Royalist) Wales and from Ireland, which at the time was partly controlled by the Irish Catholic Confederation and was generally pro-Royalist, while Henrietta Maria led recruitment efforts in France.

Yet all of these efforts were largely unsuccessful. James Butler, Duke of Ormond, a Protestant and Charles's lieutenant-general in Ireland, did not make any serious attempt to recruit Confederate Irish troops. The local population in South Wales was facing heavy burdens imposed by Charles and his leaders at a time when the Royalist cause seemed futile—a sentiment compounded by the loss at Naseby—and the Royalists were unable to enforce the quartering of troops

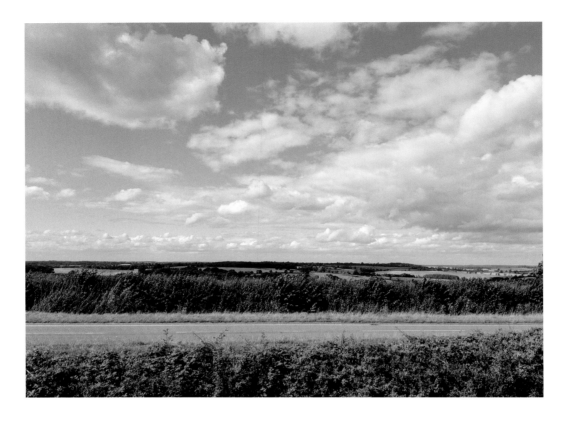

and impose levies on the resistant locals.[31] On September 9, Charles suffered another blow, when Fairfax captured Langport and Bridgwater, in Somerset, England, and Bristol was surrendered.[32] Over the course of the fall of 1645, the Royalist position became hopeless as Charles's hold on the west weakened. The scattered contingents of his army were of little value, and anticipated recruitments never materialized. Charles therefore sought to negotiate to end the war.

When Parliament refused Charles's diplomatic attempts to end the war, he continued to scheme and sought the support of the Scottish Covenanters, whose army was still in England after being contracted by Parliament. The Covenanters were inclined to switch sides and support Charles on the condition that he make Presbyterianism, instead of Episcopacy, the state religion of England. In April 1646, Charles placed himself in their hands, believing he would be welcomed as a sovereign and allowed to pursue peace negotiations with Parliament.[33] Upon his arrival to the Scottish camp at Newark, Nottinghamshire, in early May 1646, it became clear that the Covenanters did not intend to welcome him as a sovereign. Instead, Charles was treated as a prisoner and was forced to surrender Newark and Oxford to the Parliamentarians and to deliver to them his second son, James, Duke of York. Throughout the realm, all Royalist forces were made to surrender, making it undeniable that the war was over.

The Second English Civil War, 1648–49

Parliamentarian commissioners offered Charles the opportunity to resume his role as sovereign, but only as one subject to Parliament (i.e., as a constitutional monarch). If Charles were to have accepted, he would have been required to relinquish control of the army and navy to Parliament for twenty years, allow Parliament to nominate chief officers of state, agree to severe penalties for all Catholics, and abolish the Episcopacy. Charles attempted to prolong the negotiations while secretly conniving to play the Scottish Covenanters against the Parliamentarians to obtain better terms. This ultimately failed: anxious to have him in its custody, Parliament arranged a settlement with the Covenanters, whereby, for £400,000, the Scottish army would hand over the king in Newcastle, Tyne and Wear, and leave England. Thus, on February 11, 1647, Charles was delivered to the Parliamentarians.[34] He was immediately transferred farther south, out of reach of the Covenanters, to Holdenby House, in Holdenby, Nottinghamshire, and later to Hampton Court Palace, in Molesey, Surrey.

From the moment Charles was taken captive, the climate among the Parliamentarians changed. The New Model Army became agitated (most notably over arrears of pay), grew more radical in their demands, and were outraged when the House of Commons passed a Declaration of Dislike condemning them as enemies of the state. This internal conflict among the Parliamentarians gave Charles ample time to procrastinate in responding to the Newcastle propositions to resume his role as sovereign. It also forced Parliament to seriously, and favorably, consider some of Charles's counterproposals.[35] Charles used his position against both Parliament and the New Model Army to try to leverage a better deal for himself. He escaped from imprisonment at Hampton Court Palace and fled to the Isle of Wight, where he thought he would be better able to negotiate with the ability to find a ship and flee to France, should the need arise. Charles had also secretly (again) entered into negotiations with the Covenanters: he agreed to establishing a Presbyterian system for three years and to several other conditions; in return, the Covenanters would become allies and help restore him as sovereign.[36]

Meanwhile, tensions between Parliament and the New Model Army had escalated to such an extent that the army entered London, forcing the most critical leaders of the House of Commons to flee. A debate between the two sides was chaired at Putney by Cromwell, who agreed to negotiate with Charles if it would ensure peace and order throughout the country (the majority of people maintained that a satisfactory government needed a monarch as its head). Cromwell delivered a speech in the Commons on October 20, 1647, supporting continued negotiations with Charles. At the end of the year, when Parliament discovered that Charles had fled to the Isle of Wight and had a secret arrangement with the Covenanters, the Commons voted to cease negotiations.

Parliament's failure to come to a settlement with Charles was the most significant contributor to the Second English Civil War. Additionally, throughout the country there was growing resentment toward the many county committees Parliament had established during the first war to raise money and recruit soldiers, and which had subsequently been given the power to confiscate Royalist estates. This resentment led to pro-Royalist uprisings, which the Parliamentarians extinguished without great difficulty.[37] Compared to the first war, there was very little fighting in the second; the war was effectively a series of small conflicts and revolts and had only a short campaign season in the north. Within a year, the Parliamentarians defeated the Royalists resoundingly at the Battle of Preston, Lancashire, from August 17 to 19, 1648.

As soon as the second war ended, Parliament resumed negotiations with Charles, and the two parties met at Newport on the Isle of Wight. Recognizing the dangerous position he was in, Charles granted Parliament the right to control the army for twenty years; however, he would not accept a Presbyterian system for the Church of England. The dissatisfied members of the Commons and leaders of the army pushed for him to be placed on trial. Cromwell and Fairfax—who by this time were the undisputed leaders of the government and army—could no longer contain the crisis. Fairfax reluctantly agreed that Charles should be deposed, leading the army into London again, in an effort to coerce Parliament to halt its negotiations with him. When Parliament refused, 45 of its members were arrested, while another 160 voluntarily withdrew, leaving behind what came to be known as the Rump Parliament. In December 1648, the Commons voted to end discussions with Charles and to proceed with his trial.

On January 27, 1649, Charles was condemned to death as a tyrant and traitor by sixty-nine members of the High Court of Justice. John Bradshaw, president of the court, asserted that the law came from Parliament and that the monarch was subject to the law. Charles remained obstinate until the end, asserting his innocence and claiming he was a martyr. He was executed on January 30, 1649 (fig. 2.9).

The Third English Civil War, 1649–51

In early February 1649, Charles's nineteen-year-old son, who was then in Holland, assumed the title King Charles II.[38] Almost immediately after his father's death, Charles II began plotting ways to overthrow the Free Commonwealth that was being governed by the Rump Parliament. Since Royalists throughout England had been crushed and were under heavy surveillance, he was forced to gain support elsewhere.

The Scottish Covenanters harbored deep resentment toward Parliament after its execution of a monarch with Scottish ancestry. Charles II sought to take advantage of this and appointed the Marquis of Montrose as his captain-general

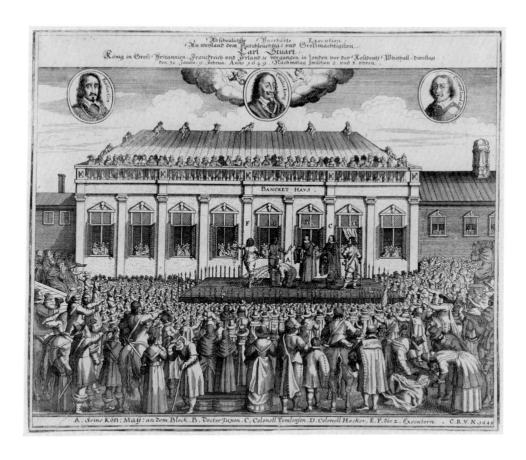

Fig. 2.9

Unknown artist, *The Execution of King Charles I*,
ca. 1649. Etching, 10¼ × 11½ in. (26 × 29.2 cm).
National Portrait Gallery, London, NPG D1306

in Scotland, to recruit troops and muster support. In Ireland, Butler, now the
Marquis of Ormond, had finally established a treaty between the Royalists and
the Irish Confederates by granting the right to freely practice Catholicism and the
independence of the Irish Parliament. In exchange, the Confederates promised to
supply Ormond with an army of over fifteen thousand. Charles II went to Dublin
to unite them. The English Parliament sent forces under Cromwell to punish the
Irish for this perceived rebellion and to suppress the Royalist movement. The Irish
were quickly subdued, and Cromwell returned to London at the end of May 1650,
leaving behind his son-in-law, Henry Ireton, with an occupation force.

On May 1, 1650, Charles II signed the Treaty of Breda with the Covenanters.
The treaty required that he instate the Presbyterian Church in England and
Scotland, repudiate his arrangements with Montrose and Ormond, and abolish
Catholicism from the entire realm. In return, he would be invited to Scotland to
be formally crowned. It was on Charles II's arrival in Scotland for his coronation
that the Third Civil War began. Although the Covenanters were not committed
to fighting for Charles II, the Council of State for the Free Commonwealth sent
Fairfax with an army into Scotland.[39] When Fairfax refused to initiate a conflict

unless the Scots acted first, Cromwell replaced him as commander. As Cromwell and the army maneuvered through Scotland, the Covenanters tried to avoid a major confrontation, counting on his retreat to England in the winter. At the end of the campaign season, on September 3, 1650, Cromwell launched a surprise attack at Dunbar. In the pivotal Battle of Dunbar, Cromwell's army captured ten thousand prisoners—half the Scottish army—and killed three thousand men while suffering minimal losses.

The Scottish Royalists' bitter defeat revived them in their cause. This, together with the Scottish coronation of Charles II at Scone, Scotland, on January 1, 1651, led to one more significant battle. Exactly one year after the Battle of Dunbar, Cromwell surrounded the town of Worcester, England, with more than twenty-eight thousand men. After three hours, they were able to subdue the Scottish army and effectively win the war. Charles II, who had fought bravely during the encounter, escaped to France by traveling through the country with the aid of Royalist sympathizers.[40]

The Commonwealth, Protectorate, and Restoration

Following his victory in the Third Civil War, Cromwell gained more influence and control.[41] He set about reforming laws, and in August 1653, backed by armed soldiers, he disbanded the Rump Parliament. He now perceived himself as commander in chief and called a new Parliament. On December 12, 1653, Cromwell assumed the rule of England, Ireland, and Scotland as Lord Protector (fig. 2.10). This new role—and the new form of government—was established by the Instrument of Government, a document designed to provide stability while ensuring the prevalence of the army. Although this document might now be seen as step back toward monarchy (or forward, toward the Restoration of 1660), it actually represented England's first practical written constitution.[42]

Cromwell had come from modest means, and as Lord Protector he imposed his views on how the courts should function and addressed relief for the poor. In 1657 Parliament voted to allow Cromwell to assume the Crown (likely due to his own efforts and persuasion). He ultimately declined, partly out of concern he would be alienating the army that had fought against the Crown during the Civil War. But at his re-inauguration as Lord Protector that year, he dressed differently than he had in 1653, wearing a purple velvet robe lined with ermine, evocative of regalia.

Cromwell's health had been deteriorating for years, and he died on September 3, 1658—the anniversary of the historic Battles of Dunbar and Worcester.[43] After his death, his third son, Richard Cromwell, was proclaimed the new Lord Protector. Yet Richard failed to manage the army and Parliament, leading to his replacement, on May 19, 1659, with the reestablishment of the

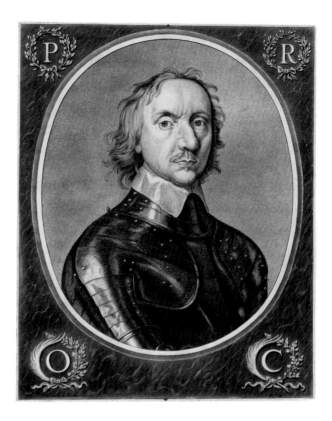

Rump Parliament and Commonwealth. Throughout the Commonwealth and Protectorate, Royalists had remained hopeful that Charles II would be proclaimed king and that there would be a return to the monarchy. After a politically chaotic period, in 1660 Charles II officially assumed the throne, and the monarchy was restored.[44]

The English Civil War era was a pivotal period in British history. It pitted the monarch and his religious clerics against a new class of ambitious men in Parliament, and it exposed long-standing religious tensions. At the end of the three wars, the nation was fundamentally changed. Parliament became a permanent fixture of the British government. The monarch no longer had the power to levy taxes without the consent of the House of Commons or the right to arrest its members without cause. The war also resulted in the formation of a standing army, which coincided with a shift in England's role in the world as it established itself as a global empire.[45] Interpretations of the events that transpired during the English Civil War have changed over the centuries, but the coins, medals, and tokens from the period—such as those displayed on the Naseby Cup—offer unique opportunities to learn more about this extraordinary time.

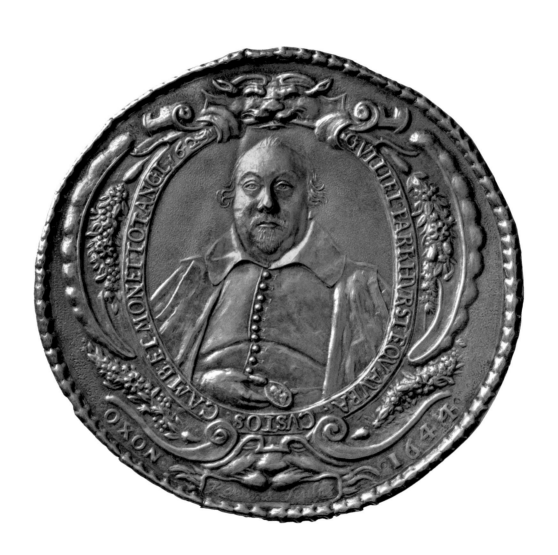

An Introduction to Coins and Medals of the English Civil War

Sir Thomas Rawlins, *Medal of Sir William Parkhurst*, Oxford, 1644. Silver, 11.74 g, 77.5 mm. Yale University Art Gallery, The Susan G. and John W. Jackson, B.A. 1967, Numismatics Acquisition Endowment Fund, 2021.33.1

The reign of King Charles I (r. 1625–49) yielded the most extensive range of numismatic pieces that Britain has ever produced under one monarch, primarily due to the English Civil War. Throughout the realm, new Royalist mints were established to strike coins for Charles's cause. There was also an increase in the issuing of medals, as they were awarded not only to officers but also, for the first time, to the rank and file, and private medals were produced on a large scale. In addition, the mid-seventeenth century saw various experiments with mechanical production for coin making—a break from traditional hand-striking methods—that contributed to the diverse mosaic of numismatics from the period. The impact and results of these events and developments can be seen in the pieces on the Naseby Cup.

Before the English Civil War, all circulating money was produced at the Tower Mint, in the Tower of London, which had been the sole official mint during the late Tudor and early Stuart periods. Historically, coins have remained in circulation for decades or even centuries after their production, since their intrinsic (i.e., metal) value was the determining factor for their acceptance in daily use. Thus, at the start of the First Civil War in 1642, much of the circulating coinage dated to the preceding decades. An Englishman during the war could have used silver coins from 1551, for example, or gold coins from before Elizabeth I's reign.[1]

At the outset of the war, the Parliamentarians immediately seized the Tower Mint. Under their control, the Mint did not produce new types of coins, enabling Parliament to claim that the Mint was still acting on behalf of the king. Therefore, the only aspect of the coinage struck by Parliament during the war that changed was the privy mark, which typically changed annually.[2] Charles, deprived of the Tower Mint, was forced to establish emergency provincial mints throughout the realm in order to finance his campaign (fig. 3.1). Located in cities such as Oxford and York, these mints produced new and different variations and types of coinage. Toward the end of Charles's reign, many Royalist castles and towns were isolated and besieged and did not have access to the regular circulating coin pool. Some besieged entities produced their own coins out of necessity, now known as "siege coins." Acting under their own authority, local bureaucrats issued coins with simple designs, often with unusual shapes and weight standards, in whatever metal was available (they were frequently struck from fragments of plate). The most prominent examples of Civil War siege coins are from Carlisle, Newark, and Scarborough; a shilling from Newark appears on the Naseby Cup (see cat. 64). Newark experienced three sieges in three years, and its siege coins were produced as an attempt to maintain the normal life of its residents. The siege coins from the Civil War not only added new coin types to the circulating pool but also testify to the strife that many people faced.[3]

The coins and medals produced during this time represent an important source for studying this era of British history. The following introduction to

Mints of the English Civil War,
1642–48

- ◆ Mint
- ● Siege-issue mint
- △ Uncertain mint

SCOTLAND

Tyne

●Carlisle

IRELAND

Tees

Scarborough●

North Sea

◆York

Irish Sea

Humber

●Pontefract

ENGLAND

Saint George's Channel

●Chester

Newark●

Trent

Shrewsbury◆

△Bridgnorth

Ashby de la Zouch △

Welland

Great Ouse

Talybont◆
Aberystwyth◆

Hartlebury△
Worcester

□NASEBY

Severn

Avon

WALES

Hereford◆

Wye

Colchester●

Oxford◆

London◆

Bristol Channel

Bristol◆

Thames

Strait of Dover

Exe

Exeter◆

Truro◆

English Channel

N

Miles
0 20 40 60 80 100

0 40 80 120 160
Kilometers

FRANCE

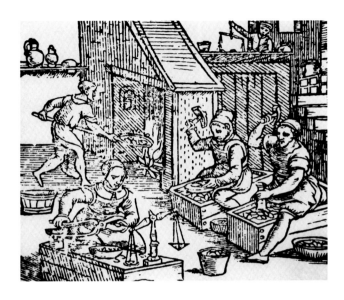

Fig. 3.1

Map of Mints of the English Civil War, 1642–48

Fig. 3.2

Unknown artist, *Minting Coins with Handheld Tools*, ca. 1550. Woodcut. Royal Mint Museum, Llantrisant, Wales

English Civil War numismatics is not intended as a comprehensive investigation of the material from the period; rather, it provides an overview of the objects produced during this time and illuminates the ways in which they relate to the historical narrative and, more specifically, to the Naseby Cup.

The Production of Coinage

The first Western coins were struck by hand in ancient Lydia (in modern western Turkey) in about 600 B.C. Later, mechanical (milled) methods were introduced as alternative means of production. What has changed over the centuries is who has control of and access to metal and the right to mint coinage, as well as the quantity and quality of the coins themselves.

In seventeenth-century England, coin production was dictated by a contract between the Crown and the head of the Mint, the Master Worker. The Mint and Master were overseen by the Warden of the Mint, who was appointed for life. Under the reigns of James I, Charles I, and Charles II, this position was filled by Sir William Parkhurst (see p. 40). The Master held the more lucrative position, because he acted as the contractor to the Crown and could profit from the rates at which he distributed work to subcontractors. At the start of the process, bullion was brought to the Mint and purchased at a price based on the fluctuating market value. Then, after minting costs and the king's "royalty" (seigniorage) were claimed, the remaining bullion was used to issue coins.

The traditional striking process was long and complicated and involved a sequence of operations with specialized, technical steps (fig. 3.2). First, the bullion was melted, assayed, and adjusted to meet the fineness (metal quality) needed to produce a particular coin type. Next, it was cast into a thin ingot that

was then reduced to the appropriate thickness through beating and annealing. Blanks, or flans, were then cut and further annealed, stacked, and hammered into a circular shape. The circular blanks were blanched by being boiled in an acid solution, which cleaned the surface before striking. Finally, the blanks were struck between two dies: the mint worker set the lower die (the "obverse die") into a block or an anvil; he held the upper die (the "reverse die") by hand as he used a hammer to strike the blank between the two dies. For this reason, hand-struck coins are called "hammered coins."

The process in which the dies were created was also complicated. Dies were made of iron and had steel faces (fig. 3.3). The designs on the faces were not engraved but rather were made using small punches. Larger elements, such as a portrait of the king, were produced with a single punch, to ensure that each coin had uniformity. Because the reverse die received the full blow of the hammer during the striking of a coin, it deteriorated more quickly than the obverse die, so that on average two reverse dies were needed for every obverse die.[4] Given the highly laborious and technical nature of the entire production process, from the creation of blanks to dies to finished coins, complications could arise at any stage.[5]

Since the production of coinage was not an exact science, denominations were fixed within a narrow range of weight and fineness (fig. 3.4).[6] Gold coinage was mainly struck at a standard of 22 karats (a fineness of 91.7 percent), known as "crown gold." Before the early Stuart period, gold coins were struck

The English Coinage System, 1625–42

1 pound (£) = 20 shillings (s.) = 240 pence (d.)

1 shilling (s.) = 12 pence (d.)

Gold	Silver
Unite (20 shillings)	Pound (20 shillings)
Double crown (10 shillings)	Half pound (10 shillings)
Angel (10 shillings)	
Crown (5 shillings)	Crown (5 shillings)
	Half crown (2 shillings and sixpence)
	Shilling (12 pence)
	Groat (fourpence)
	Threepence
	Half groat (twopence)
	Penny
	Halfpenny

Fig. 3.4

The English Coinage System, 1625–42

at a standard of 23 karats 3.5 grains, a limited number of which continued to circulate. After Elizabeth I's reign, that standard was restricted to the production of angels for ceremonial purposes. Silver coinage was struck at a fineness of 92.5 percent, a standard that remained in use until 1920. This standard had been restored in the Great Recoinage of 1560 to 1561, following the debasements (to 91.7 percent) under Henry VIII and Edward VI (r. 1547–53). Debased silver coins from the 1550s continued to circulate alongside coins struck under Elizabeth and Charles.[7]

To ensure quality, the Mint then performed the Trial of the Pyx, a process that can be traced to the twelfth century, whereby random samples of gold and silver coins were sealed in a pyx, or box, for regular (roughly annual) trials.[8] The pyx was stored in a gloomy chamber in the cloisters of Westminster Abbey known as the Chapel of the Pyx; the trials may have taken place there as well, although there is written evidence that from 1528 until 1640 the trial took place in the Star Chamber, at the old Palace of Westminster. During the trial, the weight and fineness of the coins were tested by a jury called the Court of the Star Chamber, comprising citizens and members of the London Goldsmiths' Company. The Court of the Star Chamber was abolished in 1640 to 1641, and in 1643 a new jury was established when the Privy Councillors (advisors to the monarch) formed a joint committee of members from both Houses, to which some members of the Committee of Revenue were added.[9]

Tower Mint Privy Marks under Charles I, 1626–43

	Mark	Date
⚜	Fleur-de-lis	June 29, 1626
⛫	Cross on steps	April 27, 1627
◉	"Negro head"	April 27, 1627
⛫	Castle	July 3, 1628
⚓ ⚓	Anchor (1)	June 26, 1629
♡	Heart	June 23, 1630
❀	Feathers	June 30, 1631
❀	Rose	June 21, 1632
♥	Harp	July 11, 1633
▦	Portcullis	June 27, 1634
⚲	Bell	June 18, 1635
♛	Crown	February 14, 1636/37
⊕	Tun	May 8, 1638
⚓	Anchor (2)	July 4, 1639
△	Triangle	July 26, 1640
✳	Star	July 15, 1641
◬	Triangle-in-circle	May 29, 1643

Briot's coinages

	Mark	Date
•⊕	Flower, with *B*	1631–32
⚓	Anchor, with *B* or a mullet	1638–39

Fig. 3.5

Tower Mint Privy Marks under Charles I, 1626–43. Adapted from: Besly 1990, 10

In an additional effort to ensure quality, each die was given a privy mark, or what numismatists call a mintmark or an initial mark: a small symbol, such as a harp or rose, that indicates some aspect of a coin's production (most often the mint, moneyer, or another element of the coin's origin) and/or prevents counterfeiting. The Tower Mint changed the privy mark annually, shortly after Lady Day (March 25), when the legal year started (fig. 3.5).[10] Today, these marks allow numismatists to date coins that otherwise do not have any indication of their production date. The two quality-control methods—the Trial of the Pyx and the use of privy marks—were imperative for the stability of the economic and monetary system, because the face value of coinage was closely tied to its intrinsic value.

The influx of silver from the New World in the sixteenth century led to an increase in silver coin production in England and throughout continental Europe.[11] Large silver coins weighing up to one ounce were already being struck in Austria and Germany in the early 1500s as replacements for gold coins of the same value, but England did not immediately follow suit. Henry VII (r. 1485–1509) had experimented with testoons (shillings of twelve pence) around the

turn of the century, but they did not become regular currency until the debasements in the 1540s. During the Great Recoinage of 1560 to 1561, the Tower Mint finally began to produce shillings in large quantities. The Mint first struck bigger coins, crowns and half crowns, in 1551 to 1553, but in minimal quantities. Only under Charles I were crowns and half crowns made in such quantities as to become regular fixtures of the circulating coin pool.[12]

One of the main reasons that very large silver coins were not common in Charles's reign was England's failure to adopt the latest mechanical innovations for production. The traditional method of hand producing coins could not accommodate the size of a large coin. Only two proper experiments with coining machines were undertaken in England, both by Frenchmen. The first was the screw press, implemented from 1560 to 1571 by Eloy Mestrelle. The second was the rotary mechanism implemented by Nicolas Briot, who came to London from the Paris Mint in 1625 and would come to play an important role during the Civil War. In London Briot received an annual salary of £50;[13] he engraved most of the effigies for the Tower Mint coinage, and he produced some issues using experimental rotary mechanisms in 1631–32 and 1638–39. Despite the higher aesthetic quality they achieved, these mechanisms had significant issues, especially in controlling the weight of individual coins as well as in the speed of production, thereby making them ineffective for serious implementation. Additional machine-coining experiments occurred after the Civil War, during the Commonwealth and Protectorate, and mechanical production became the standard in 1663, following the Restoration.[14]

Mechanized production offered greater control of artistic quality and the ability to produce larger silver coins. Rotary-press production had two variant mechanisms.[15] The first was a rocker press, in which a single pair of dies was mounted in pockets on axels that were geared together. A strip of alloy metal was passed through the press, and the blanks were then cut out, tested for their weight, flattened again, annealed, and then blanched. The second mechanism, a cylinder press, resembled a mangle (a machine with two rollers through which wet laundry is squeezed). It consisted of a series of dies mounted on a pair of steel cylinders that were geared together, one on top of the other. After a strip of metal alloy was annealed and blanched, it was passed through the cylinders. The coins were then punched out of the strip and rolled in sand to remove sharp edges. Although the cylinder press was used for private issues of copper farthings under James I and Charles I, as well as for Briot's Scottish "Stirling" turners (two Scottish pence, the equivalent of one-sixth of an English penny), only the mint at York used the cylinder press to issue precious-metal coins.[16]

Some of the coins on the Naseby Cup were produced using the traditional hand-striking method, but others were made with these innovative machines. The style and quality of a coin are the main characteristics used to determine

whether it was hammered or machine-made. Compare, for example, two coins of Charles I, a hammered shilling (see cat. 52) and a machine-made twelve shilling (see cat. 19); the detail of the latter is noticeably sharper. Taken together, the coins on the Naseby Cup therefore reflect the transition from traditional hammered production to a modern, mechanized system.

The Production of Medals and Badges

The commemorative medal, as we understand it today, was conceived in Italy during the Renaissance as a personal object that could serve as propaganda: it glorified or memorialized (or, in some cases, criticized or satirized) its subject. While the portrait on the obverse of a medal was crucial to conveying the subject's personality and importance, the design on the reverse further refined this impression by presenting heraldry or a reference to a significant event or unique attribute that the viewer would be expected to associate with the subject. Today, commemorative medals reveal how the subjects wanted to be perceived or how they perceived themselves.[17]

England was slow to follow the Italian trend of producing medals. The first known portrait medal of an Englishman is that of John Kendal (fig. 3.6), who raised an Irish army to defend the island of Rhodes during its siege by the Ottoman Turks in 1480. During the reigns of Henry VIII and Elizabeth I, medals were produced with increasing frequency but still remained rare, and production in England only really accelerated in the 1630s.

A great quantity of medals were produced in the English Civil War period, due in part to the growing use of medals as rewards for military merit. Although the production of medals to commemorate events and reward leading men dates back to antiquity, the Civil War marked the first time that the rank and file were more frequently rewarded with medals for their service (see figs. 1.2–.3 and 2.5, and cats. 8 and 12). As more people obtained medals, others were inspired to procure pieces testifying to their own allegiances, thus generating further demand for private enterprises to create badges and medals.[18] A pro-Royalist citizen, for example, might have worn a badge of Charles I to express allegiance to the king (see cat. 2).

Much remains unknown about the medals of the Civil War period. Very few documents pertaining to their manufacture survive. If, at one time, there was more documentation, it is possible that it was destroyed by either side during or after the war, in an effort to remove traces of the opponent. Following the Restoration, documents of the Commonwealth would have been targeted by the monarchy; supporters of the Commonwealth may even have destroyed their own records in self-preservation. To complicate matters, a great number of medals were privately manufactured, and documentation of them may never have existed in the first place.[19]

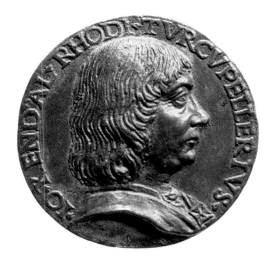

Fig. 3.6

Attributed to the manner of Niccolò Fiorentino (Niccolò Spinelli), *Medal of John Kendal*, 1480. Bronze, 83.02 g, 57 mm. British Museum, London, 1866,0920.1

Medals commemorating the Royalist cause outnumber those of the Parliamentarians and Commonwealth, and Charles I is the most frequent portrait subject on medals and badges of the period (see cat. 6). His wife, Henrietta Maria, also appears on several pieces (see cat. 7). The immense variety in the Royalist medals known today indicates that a wide range of materials and methods were employed in their production. Most were made of silver or silver gilt (silver gilded with gold), although some were made of gold or base metals. The medals—even some with the same designs—also appear in different sizes, as dictated by the recipient's or commissioner's status and wealth, which would have required different casting or striking techniques. The variations in subject, material, size, and technique among extant medals, many of which are known through only a few specimens, suggests an abundance of diverse medals during this time.

Engravers and Medalists of the English Civil War

The Civil War era was a pivotal period in numismatic production in England, as the country transitioned from using traditional methods to implementing experimental machinery for coins, and as medals grew increasingly popular. Despite the fact that England was slow to adopt innovations being used elsewhere in Europe and relied on foreign medalists to initiate the first trials, some of the greatest numismatic materials from the mid-seventeenth century were produced in Britain.

As previously discussed, Nicolas Briot, who was born in France, was one of the first figures to implement mechanized coin production in England. Briot was never strictly a medal engraver, and the medallic work he did undertake was hardly prolific (nor was his numismatic work in France). Briot was instead obsessed with the use of machines and the immense profit he could reap should

they ever be fully integrated at the mint. While his contribution to engraving and medallic art was minor, his contribution to coinage was far more substantial.[20] When Briot first arrived in London from the Paris Mint in 1625, Charles I commissioned him to make dies for pieces of largesse of gold and silver to commemorate his coronation. This project established Briot's reputation, and he went on to produce a considerable number of dies for coins and medals for the Tower Mint in the following years. In 1635 Briot was appointed the Master of the Scottish Mint, and he installed his machinery at Edinburgh beginning in 1637. In 1642 he returned to London, where he received an annual salary of £250, and he prepared equipment for the Royalist mints at Shrewsbury and York, the latter of which used rotary mechanisms, as did some of the other Royalist mints.

Another important numismatic figure of the Civil War era was the engraver Thomas Simon. The first in-depth study of Simon and his work was made by George Vertue in 1753—less than a century after Simon's death in 1665—testifying to his significance to British numismatics.[21] Vertue wrote that Briot had discovered Simon's skills around 1633. While there is no evidence to support Vertue's claim,[22] Simon was first employed at the Tower Mint in 1635 as an apprentice to Chief Engraver Edward Greene, though he likely acquired much of his artistic skill directly from Briot, Greene's supervisor for artistic matters. As Simon's mentor, Briot doubtless instilled in him the importance of mechanized production.

At the outbreak of the First Civil War in 1642, Simon (a Puritan and Londoner) sided with Parliament and remained at the Tower Mint. On May 22, 1642, Parliament ordered Simon to produce a copy of the Great Seal for its own use—an act that Royalists regarded as high treason. When Greene died in 1644, Parliament appointed Simon and Edward Wade as joint chief engravers (each with an annual salary of £30). Charles, of course, disregarded these appointments and made Thomas Rawlins "Chiefe Graver to His Mats [Majesty's] mint at the Tower of London and elsewhere in England and Wales."[23]

The first issues of coinage from the Tower Mint under Parliamentarian control were produced at a high quality and standard and resembled the style of Briot's earlier crowns, indicating Simon's involvement. Later coins were mediocre, which suggests they were by Wade, an attribution supported by the fact that, during most of the Civil War and especially toward the end of Charles's reign, Simon focused his energy on the production of medals and seals. This included a 1646 memorial medal of Robert Devereux, the Third Earl of Essex (for an example of an earlier medal of Devereux, see cat. 12).[24]

After the execution of Charles I in 1649, Parliament could no longer maintain that it was striking coinage on behalf of the king and therefore decided to issue new coins bearing the name of the Commonwealth and new iconography

(see, for example, cat. 31). For the first time, the coins were to have legends in English, instead of Latin, along with simple designs. These new coins were not the pinnacle of numismatic art: their design was deliberately plain and simple in style, and the coins themselves displayed the defects of hammering; some were so thin and poorly struck that it was impossible to distinguish clipped from unclipped coins.[25] In addition, the privy marks—the sun (1649–57) and anchor (1658–60)—were in use for such long periods that the marks themselves no longer served their intended purpose. In 1650 Parliament formed the Committee for the Mint to ascertain how the Commonwealth's coinage could be improved.

Simon was appointed chief engraver to the Tower Mint on April 21, 1649, although it is not clear what role he played in planning and producing new coins for the Commonwealth. Given his artistic skill and talent, it is difficult to envisage his involvement with these unrefined coins. It is possible that either John East (Simon's assistant) or Nicholas Burgh (associated with East) was responsible for their design. Whatever the case, it appears that the duties and products of the three engravers overlapped for a number of years, until Simon was confirmed as sole chief engraver by Cromwell in 1656. Meanwhile, Simon had continued to focus on medals and seals, with one notable exception: his work with Pierre (Peter) Blondeau.

While Parliament was debating the shortcomings of its new Commonwealth coinage, it invited Blondeau, a French mint engineer, to come to England to improve its production mechanisms. His arrival sparked more opposition to the use of machinery in the minting process, much like Briot had experienced upon his arrival in 1625. Blondeau claimed that he had an advanced method for engraving the edge of the coin, thereby preventing clipping and counterfeiting. In the traditional *virole brisée* method, a collar engraved with an inscription was placed around a blank at the time of machine striking; the blank would expand under the pressure of the machine, and the inscription would be engraved in relief on the edge of the coin. This method could only be used with thick coins. Blondeau offered a new, secret method that could be used with any coin.

In 1651, after a year and a half of inaction, the Committee for the Mint decided that Blondeau and David Ramage, leader of the moneyers at the Mint, who had previously worked with Briot, would submit for consideration patterns and presentation pieces for improved Commonwealth coinage. Ramage and the Tower Mint moneyers used the *virole brisée* method, in hopes of preventing change in coin production. Ramage relied on his rudimentary knowledge and older machines and techniques to produce twelve pieces in half crowns, shillings, and sixpences.[26] Blondeau worked at Simon's house using the equipment Simon had. Since Blondeau was an engineer, he relied on Simon to produce

the dies (some of the few coin products that can be attributed to Simon). With his help, Blondeau produced three hundred pieces of the same denominations, implementing a design similar to the regular hammered Commonwealth issue—but with significantly better workmanship. When Blondeau's and Ramage's sets of products were compared side by side, there was no question that Blondeau's was superior, and the Committee selected his plans for the new coinage. Yet the Corporation of Moneyers blocked the Committee's decision, and Blondeau and Simon's production mechanism was not implemented in the end.[27]

In addition to his contribution to Blondeau's experiment, Simon produced several notable medals and seals, including a medal commemorating Cromwell's victory at the Battle of Dunbar (see cat. 8). This medal was well received by Cromwell himself, giving Simon a powerful patron and supporter. Cromwell commissioned several other medals by Simon, such as one commemorating his elevation to the Protectorship (see cats. 16 and 20). After he confirmed Simon as the sole chief engraver on July 9, 1656, Cromwell called upon him and Blondeau to work together to produce new portrait coinage. This time, they were finally able to use Blondeau's production mechanism—six years after they had first demonstrated its superiority in the set made for the Committee.[28]

The new portrait coins of Cromwell were never properly issued and are now known only as patterns (see cat. 27). Those produced in 1656 were part of a limited issue that was not intended to replace the hammered coins that were still being struck at the Tower Mint. Those dated to 1658 were possibly intended as tests for the full-scale replacement of hammered coins; however, since Cromwell died in 1658, this never came to pass, and the coins were never legalized for circulation.[29] Instead, they were retained as souvenirs, hoarded for their beauty, and sold at a premium. Today, they are considered some of the best-designed and best-executed English coins (see cats. 27, 36, 49, 61, and 63).[30] After Cromwell died, Blondeau returned to France, and Simon produced his last known medal for the Protectorate, commemorating Cromwell's death (see cats. 26 and 32).

When Charles II returned from exile on May 29, 1660, there was confusion surrounding the position of Chief Engraver to His Majesty and the Mint. Both Simon and Rawlins seemingly held the position—Simon having been appointed by Parliament, and Rawlins by the late Charles I. Simon petitioned Charles II for a pardon shortly after the latter returned and was named king. Since he had produced the Great Seal in 1643, Simon was granted amnesty and was permitted to remain at the Tower Mint, though not as chief engraver. Charles II felt obligated to honor his father's commitment to Rawlins, and thus in June 1660 Rawlins was officially recognized as chief engraver.[31]

Rawlins is said to have studied under Briot, with whom he worked at the Tower Mint. Like Briot, Rawlins was not strictly a medalist but was also respon-

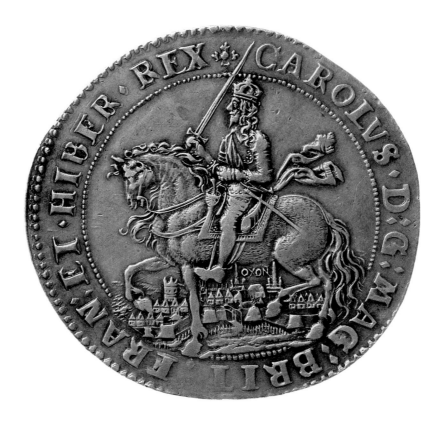

sible for the dies of several coins. For the Royalist mint at Oxford, he produced dies for the twenty shilling dated to 1642 and the extremely rare triple unite dated to 1644. The most famous coin from Oxford is Rawlins's 1644 Oxford crown (fig. 3.7), on which the city skyline can be seen underneath Charles I's standard equestrian portrait type, which resembles Anthony van Dyck's painted equestrian portrait of the king (see p. 24). Only a handful of original 1644 Oxford crowns are known to exist, but numerous cast copies were made later (see cat. 15), followed by even more electrotypes.[32] Identifying Rawlins's work is not always easy, as he did not include his signature on his coins before the 1644 Oxford crown. Three medals on the Naseby Cup (see cats. 6, 7, and 10) are representative of the type of work Rawlins undertook for Charles I (see also p. 40).

During the Commonwealth and Protectorate, Rawlins fled to France. He later returned to England, working as a die-sinker, engraving tradesmen's tokens for Bristol, Gloucester, London, and Oxford, before being appointed chief engraver by Charles II.[33] Despite having received the title of Chief Engraver, Rawlins was paid less than Simon, and he did not engrave the dies for the hammered coins of 1660 to 1662. His only known works during those years are badges and medals. In fact, in the first year and a half of Rawlins's tenure, all of the work at the Mint was Simon's, including the Great Seal of Charles II and several important medals, such as his Coronation Medal.

Simon's continued employment at the Mint following the Restoration attests to his skill and ability: the new Restoration government would have considered it a great concession to favor the man who had engraved seals for the Commonwealth and Protectorate as well as Cromwell's portrait coins. Simon was tasked with replacing the Commonwealth coinage with new coins of Charles II. Just like Briot and Blondeau, he faced resistance to machine producing coins at the Mint. Having grown accustomed to engraving dies for milled coinage, he procrastinated making dies for hammered coinage, showing his disdain for the inferior technique, until eventually, on September 21, 1660, the king ordered him to proceed. Simon produced very fine dies, but much of his workmanship was lost when the coins were hand struck. On May 17, 1661, the king ordered that all coins be made with machinery as soon as possible to prevent clipping and counterfeiting. Blondeau returned as an engineer and was reunited with Simon. Time was of the essence: by November 30, 1661, Commonwealth coinage would no longer be used for legal transactions.[34] Coin production at the Tower Mint under the monarch had fully resumed, marking the end of the chaotic years of the Civil War.

Hoards from the English Civil War

Periods of unrest often yield vast quantities of numismatic material. This typically occurs for two reasons. First, the opposing sides in a conflict create new and many types of coins, medals, tokens, and badges to finance and promote their cause. The second reason is that, during such periods, people often hide or store their valuables, in some cases even burying them in the ground—and some valuables go unrecovered after the conflict. Both of these things occurred during the English Civil War era.

As we have seen, both Parliament and Charles I—followed by the Commonwealth, Protectorate, and Charles II—made new coins, medals, and badges to finance their efforts and advance their causes. People hoarded these numismatic materials during and after the war, creating a continuous loop: as coins were withdrawn from the circulating coin pool, more coins had to be produced to replace them.

A unique feature of the Civil War is the sheer number of hoards from the period that have been recovered from the ground in England and Wales.[35] There are many reasons why people would have deposited their wealth and valuables in the ground: they may have been hiding their money after being conscripted or volunteering to fight; concealing their wealth in hopes of avoiding taxes, which were levied by both sides; or trying to hide their valuables from anyone looking for quick loot. Some numismatic material could have ended up in the ground by accident, when a person dropped a purse. The Civil

War hoards that are known today are those that went unrecovered—the original owners may have died (possibly in battle) or simply forgotten where their treasure was buried.

Gold coins are rarely recovered in hoards from this era, generally reflecting their limited availability and the fact that people who were wealthy enough to have gold were less likely to have a need to bury it. Hoards in which gold has been recovered are primarily located in south and east England, where there was a concentration of wealth. Despite this geographic concentration, it is important to note that these finds do not fully reflect the actual availability of gold in those regions; since there was little fighting and campaigning in the area, anyone who had hidden their valuables had a better chance of recovering them after the conflict.[36]

The majority of hoards consist of silver coins, due in large part to the influx of silver mined by the Spanish in the New World that had led to increased coin production throughout Europe in the sixteenth and seventeenth centuries. Shillings and sixpences, the highest-value silver coins produced in any significant quantity before Charles I's reign, are the silver denominations most frequently found in Civil War hoards. In 1632 the silver half crown (see cat. 17) became a more important denomination in circulation, and during the war the Tower Mint and Royalist mints prioritized the output of the half crown, which represented the daily pay for a cavalryman. This allowed the mints to simplify production while simultaneously making conveniently valued coins available.[37] As a result, most hoards contain a significant number of half crowns as well.

As for the coins and medals on the Naseby Cup, it is impossible to determine whether they were found together in a hoard on the Naseby battlefield or were recovered individually, as pieces lost in the midst of the action. Of course, not all of them were from Naseby: some date to after the 1645 battle, and others have no connection to the battle and instead were added to the cup in a purely ostentatious display of wealth. It is possible to speculate that there was a cache of materials buried before the battle—consisting of some of the various coins as well as the Britannia figure (see fig. 1.13)—that the original owner (possibly a fleeing Royalist or a person who died or was wounded) was later unable to retrieve. Perhaps it was discovered by some lucky laborer right there on Naseby field. Nevertheless, without clear documentation or remaining original patina to help us determine which pieces were lost or buried together, this mystery remains unsolved.

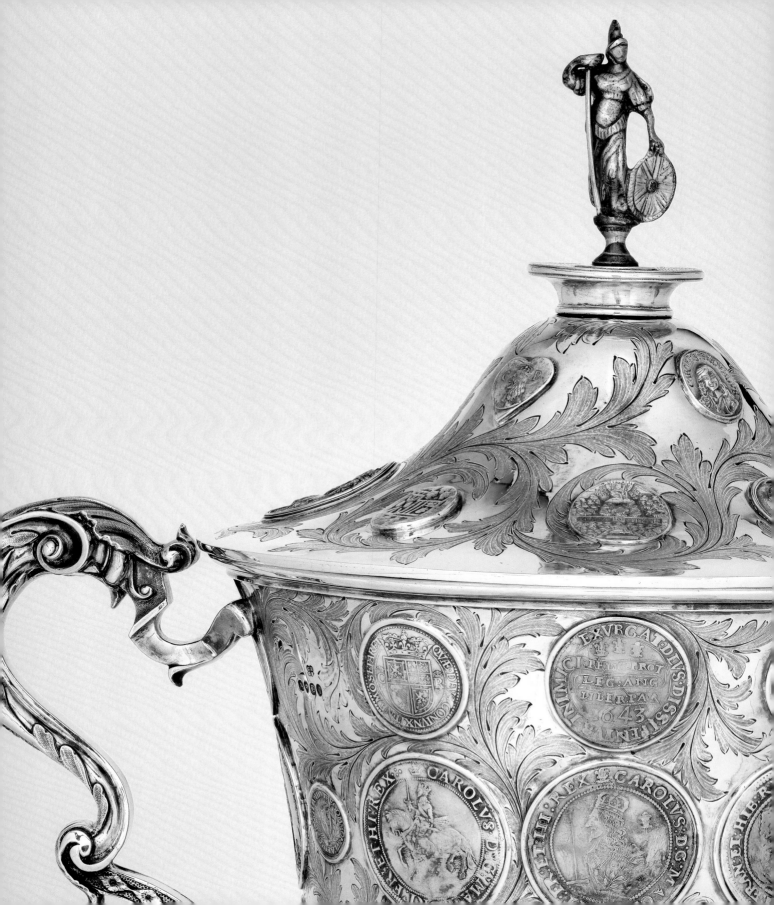

Catalogue

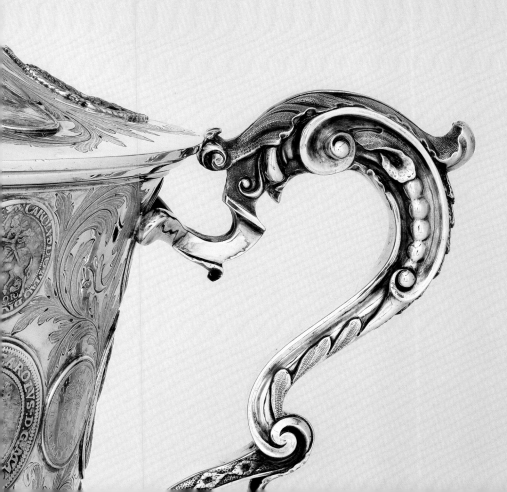

Note to the Reader

The numismatic objects on the Naseby Cup are presented here in the order in which they appear on the cup, beginning with the lid and moving clockwise around the body, from top to bottom in rows. Though some objects were installed to display the obverse on the exterior, others display the reverse. Since each object was slightly reshaped to fit into a bezel-like frame that was then soldered into the cup, the dimensions of the objects are not included. Similarly, because the objects were integrated into the cup in this way, it is impossible to record their weight. When known, the location of the mint where the object was made is provided.

Illustrations

Each object is represented with two illustrations: the illustration on the left shows the object as it appears on the exterior of the cup; the one on the right shows it on the interior. Some of the objects have been magnified, and some illustrations have been rotated. Given the challenge of photographing the interior of the cup, some illustrations are less crisp or have shadows.

Numismatic Terminology

The word "legend" refers to any inscription on an object. "Obverse" and "reverse" refer, respectively, to the front and back. A "pattern" is an experimental coin or issue that was produced to test a new design, material, or technology. Patterns were not legal tender, and some were never approved. Sometimes patterns were struck in a different metal from the one ultimately used for the approved and released coinage.

It is standard numismatic convention to cite coin or medal types when possible. A "type" is a designation for a group of coins or medals with a certain design and/or date. Numismatists have identified and named these types using their own organizational systems. Since each numismatic publication has a unique convention for organizing types, a single object could have multiple type citations. Types often have subtypes, variations with minute differences that do not merit the creation of a separate type; subtypes may be denoted by a letter following the type number. The citations included here are not all-inclusive for the field of English Civil War coins and medals but feature some of the most important and commonly encountered reference works.

Jones II = Jones 1988

M.I.i. = Hawkins, Franks, and Grueber 1969

Murray = Murray 1970

Noe = Noe 1973

North = North 1991

Platt and Platt = Platt and Platt 2013

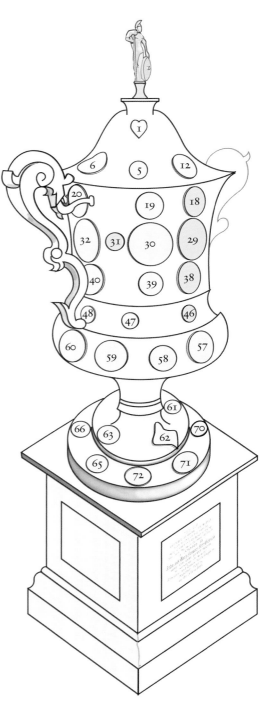

Front, view from the left

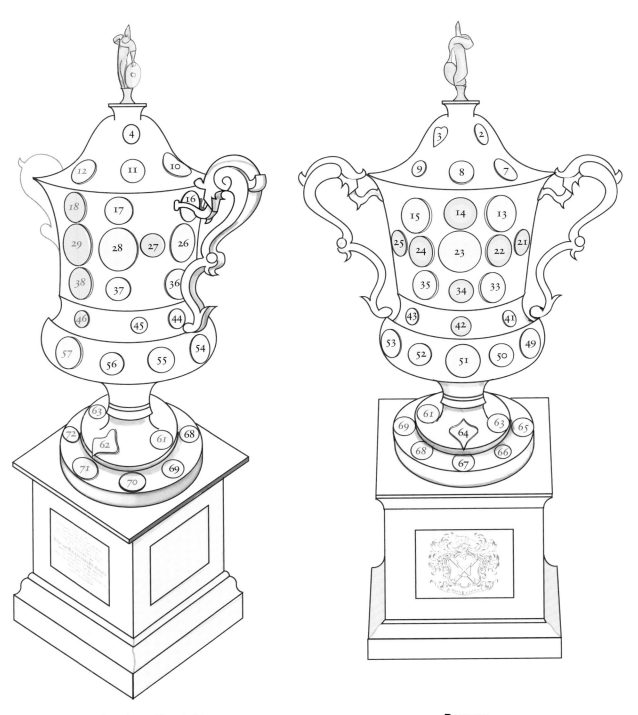

Front, view from the right

Reverse

1 and 3

Locket of Charles II and Catherine of Braganza

1662

Silver

M.I.i. 483/96 (marriage badge type)

Marriage badges were probably made for popular sale to commemorate the king's nuptials. Heart-shaped lockets imitating marriage badges, like this one, were also made in considerable numbers. Today they are all, to some extent, rare, because their craftsmanship was not particularly refined and thus few have been preserved. This locket is a deviation of marriage badge type M.I.i. 483/96 that is missing the inscription. Here, it has been split in half: one side shows King Charles II, and the other shows his wife, Queen Catherine of Braganza. While the badge and locket do not have a date, the queen's style of dress suggests the piece was produced around the time of the marriage in 1662.[1]

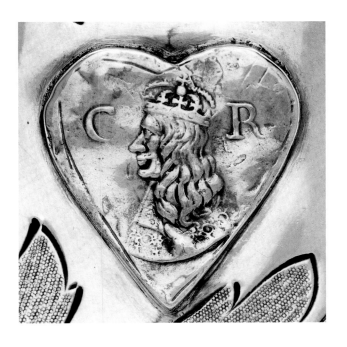

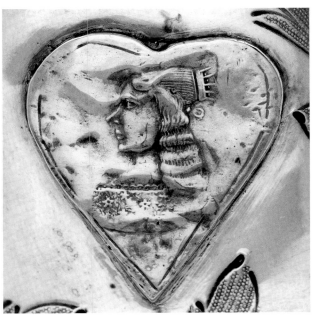

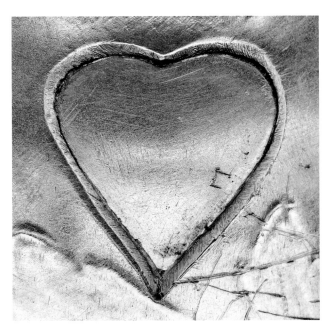

2

Badge of Charles I

ca. 1648–early 1660s

Silver

M.I.i. 361/235, Platt and Platt type I

This badge of King Charles I was most likely worn as a declaration of loyalty to the king or as a memorial after his execution in 1649. Charles is depicted with a hairstyle known as a lovelock, wearing a falling collar, armor, and a scarf across his chest. The reverse is incused with the royal arms within the Order of the Garter (the oldest and most senior Order of Chivalry in Britain), surmounted by a crown. While most badges of this type were cast in silver or silver gilt, there are a few examples in gold. This specimen originally would have had top and bottom loops and side projections, but they were filed down so the badge could be integrated into the cup.[2]

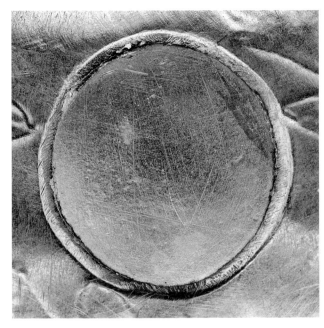

4

Badge of Charles II

ca. 1649–60
Silver
M.I.i. 439/6

This badge shows a three-quarter view of Charles II with long hair, wearing armor with lion heads depicted on the shoulders. Badges of the original type were cast silver and have an incuse legend that reads "CAROLVS · SECVNDVS"; however, the quality of this piece is crude and basic, indicating that it may have been cast from the original and then retooled, as a cheap imitation. This is further evidenced by the lack of a reverse. The reverse for the original shows the royal shield within the Order of the Garter, topped by a crown between the initials *CR* (for Carolus Rex).

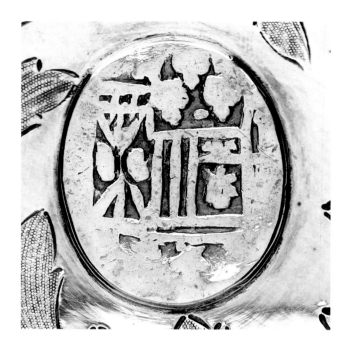

5

Cob [4 Reales?] of Philip V

Mexico City, early 1700s
Silver

Although some Spanish and Spanish American silver coins have been found in Britain, the inclusion on the cup of this Spanish American cob of King Philip V of Spain (r. 1700–1724; 1724–46)—which is displayed upside down (probably unintentionally)—is unusual.[3] During the seventeenth century, England relied on silver imported from Spanish mines in the New World. If John and Mary Frances Fitzgerald were familiar with that monetary history, they may have included the cob as a reference to it. It appears that the coin was cut down into an oblong shape to fit the contour of the lid, and the coin's denomination therefore cannot be certainly determined, since doing so would require its original weight or size.

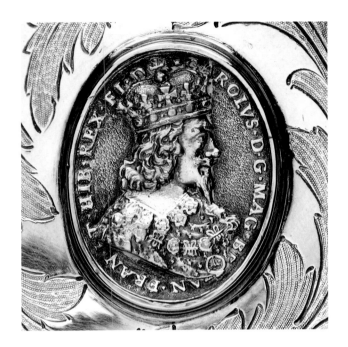 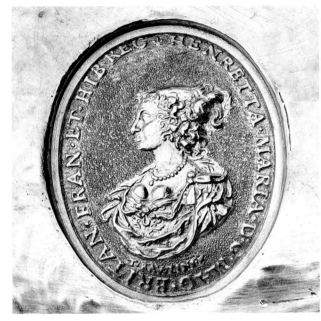

6

Badge of Charles I

ca. 1642–45

Silver

M.I.i. 355/216, Platt and Platt type B

On the obverse of this oval badge, Charles I is depicted with long hair and a crown, a falling lace collar, ermine robes, and the collar of the Order of the Garter. The legend reads, "CAROLVS · D · G · MAG · BRITAIN · FRAN · ET · HIB · REX · FI · D ·" (Charles, by the grace of God, King of Great Britain, France, and Ireland, Defender of the Faith). The reverse shows his wife, Queen Henrietta Maria, whose portrait is similar to that on the badge of Henrietta Maria (see cat. 7) but has an additional legend and the signature of the engraver Thomas Rawlins. This badge of Charles, cast in silver, has a narrow border and is heavily pitted and corroded.

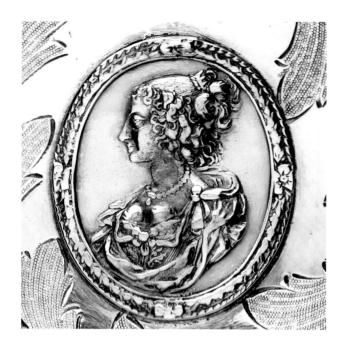
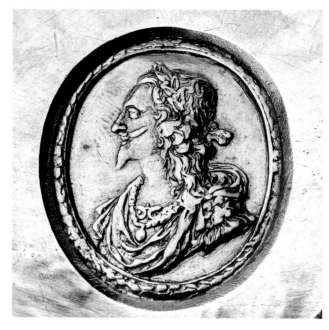

7

Badge of Henrietta Maria

before 1643

Silver

M.I.i. 355/218, Platt and Platt type A

Few portraits of Henrietta Maria appear on Royalist medals, and those that do are nearly identical. The queen's portrait on the reverse of this oval badge is similar to that on the badge of Charles I (see cat. 6), though this object has a different obverse portrait of the king. Within the floral and corded border, the queen is shown with her hair straight at the top, curly at the sides, drawn through a small coronet, and tied with a bow. She wears a pearl necklace with a pendant and a figured bodice with a brooch. Although it has no signature, the badge is often attributed to Thomas Rawlins due to its superior quality. Despite the fine workmanship in the queen's portrait, however, the style of the king's image differs from that in other works attributed to Rawlins.[4]

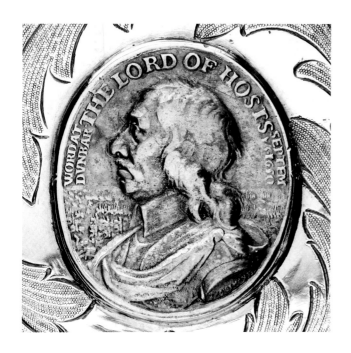

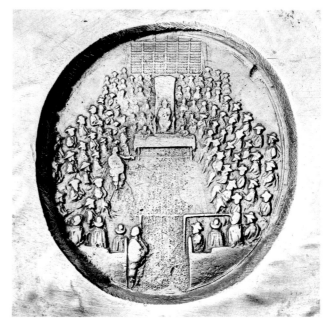

8

Medal of Oliver Cromwell (Dunbar Medal)

1650(?)
Probably silver
M.I.i. 392/14, Platt and Platt type C
or N[5]

The original Dunbar Medal was a military reward for officers and soldiers who fought at the Battle of Dunbar, Scotland, on September 3, 1650.[6] On September 7, the House of Commons resolved to thank Oliver Cromwell for his service and victory at Dunbar and to produce the medals. In a letter from Edinburgh dated February 4, 1650, Cromwell made a suggestion for the design. Thomas Simon, chief engraver to Parliament, went to Scotland to take the "effigies, portrait or statue of the Lord General to be placed on the medal."[7] The obverse shows Cromwell with long hair, in a plain falling collar, armor, and a scarf. Behind him is the battle (the horizon is an important aspect for identifying the subtype). The legend reads, "THE LORD OF HOSTS · WORD · AT · DVNBAR · SEPTEM : Y · 3 · 1650," and Simon's signature, "THO · SIMON · FE ·," appears underneath Cromwell's shoulder. The reverse shows Parliament assembled in one house with the Speaker.

There are countless specimens of the Dunbar Medal with several variations and subtypes, although the vast majority are not originals; they are instead later restrikes from the original dies, strikes from newer dies, casts of original medals, or casts of copies.[8] One explanation for this is that, sometime before 1753, the original dies were rediscovered in a former home of Richard Cromwell, Oliver's son. After this discovery, some medals were struck using the dies in copper and silver, but their later origin can be determined by cracks and rust marks.[9]

9

Medal of John Lilburne

1649

Silver

M.I.i. 386/4, Platt and Platt type B (medal type)

John Lilburne was one of the most contentious personalities of the English Civil War, and he served with the Parliamentarian army. As an advocate of the rights of the individual as opposed to the rights of the king and Parliament, he was imprisoned and fined numerous times—by both the Royalists and Parliament—for his political and religious activism. Nevertheless, after every acquittal he sought a new (sometimes imagined) archenemy. Lilburne was popular during his lifetime, but his personality and tendency to attack those in power eventually led to his demise.[10]

This medal type is very rare, and this specimen is a variation of the type without the legend. It is unclear whether this represents a new, hitherto unknown type or whether the legend was tooled away when the cast from the original medal was made.[11] The obverse depicts a portrait of Lilburne, while the reverse shows his family arms and the date of one of his trials, October 26, 1649. Lilburne had published pamphlets accusing Cromwell and his son-in-law Henry Ireton of high treason, which led to a mutiny of the Oxford regiment.

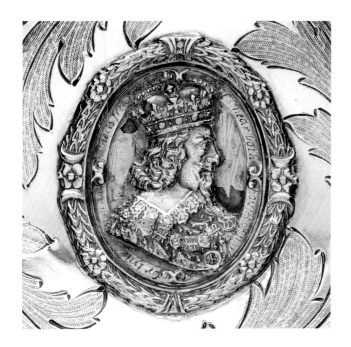
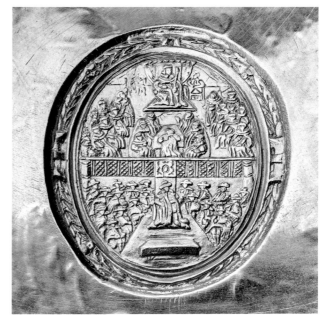

10

Medal of Charles I (Declaration of Parliament Medal)

1642
Silver gilt
M.I.i. 292/108, Platt and Platt type A

The Declaration of Parliament Medal commemorates Parliament's goal at the beginning of the war to reach an agreement with the king, as described in the incuse legend: "Should hear both houses of parliament for true Religion and subjects fredom [*sic*] stand." Charles I appears in regal style, with a crown, a falling lace collar, ermine robes, and the collar of the Order of the Garter and Great George, all within a wreathed border. The reverse shows the two Houses of Parliament with the king (seated at the top) and Speaker (standing below), also within a wreathed border. There are three types of Declaration of Parliament medals, each very rare. The type seen here is cast and chased in silver gilt. This medal originally had loops at the top and bottom (the top, where the larger of the two loops was, has been unevenly cut and filed). Even though the medal is unsigned, it has been attributed to Thomas Rawlins.[12]

11

Medal of Charles I

ca. 1642–48

Silver

M.I.i. 360/231, Platt and Platt type AA

The obverse of this medal shows a bust of Charles I with long hair over a plain falling collar edged in lace, with a scarf and a sash or ribbon for a medal. The incuse legend reads, "CAROLVS · D · G · MAG · BRI · FR · ET · HIB · RX ·" (Charles, by the grace of God, King of Great Britain, France, and Ireland). On the incuse reverse, the royal arms appear within the Order of the Garter, topped with a crown, all encircled by the motto of the Garter: "HONI · SOIT · QUI · MAL · Y · PENSE" (Shame on him who thinks evil of it). There are ten variations of this medal, indicating that it was in large demand.[13] The remnants of a loop that was filed down are visible at the top of Charles's head.

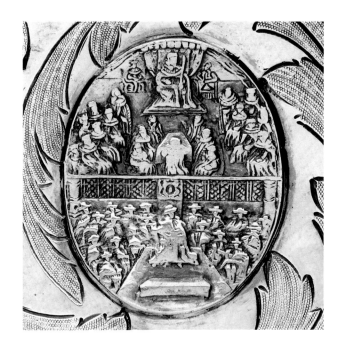 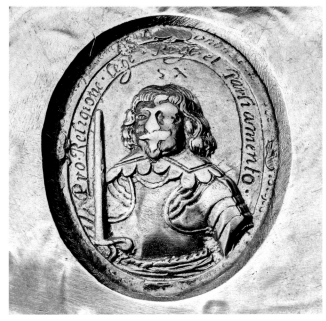

12

Medal of Robert Devereux

1642
Silver
M.I.i. 295/113, Platt and Platt type A

Robert Devereux was the Third Earl of Essex and general of the Parliamentarian forces until 1645. He appears on the obverse of this medal with a long incuse legend. The outer line (partially obscured through the melding process) reads, "Should hear both houses parliament for true Religion and subjects freedom stand," and the inner line, "Pro · Religione · Lege · Rege · et · Parliamento ·" (For Religion, Law, King, and Parliament).[14] The reverse depicts Parliament with the king and Speaker. Although the pairing of a portrait of a Parliamentarian general with an image of the king may seem unexpected, Essex did not have the same contempt for Charles I that other leaders such as Oliver Cromwell did.[15] This medal was awarded to troops in the Parliamentarian army and would have been suspended on a loop. The reverse has a filed-down suspension where the loop was once connected.

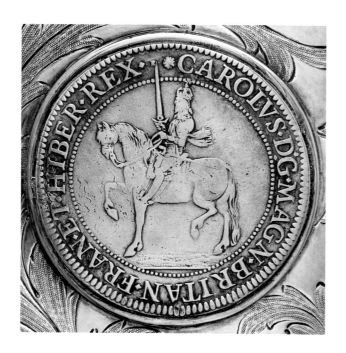

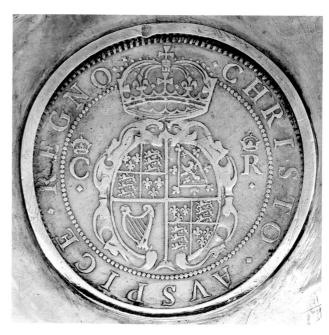

13

Crown of Charles I

Tower Mint, 1631–32

Silver

North 2298, Briot's first milled issue

This coin was part of Nicolas Briot's first milled issue at the Tower Mint in London. His initial, *B*, is included on both the obverse (at the top, near the tip of Charles I's sword) and the reverse (at the top left, by the crown).

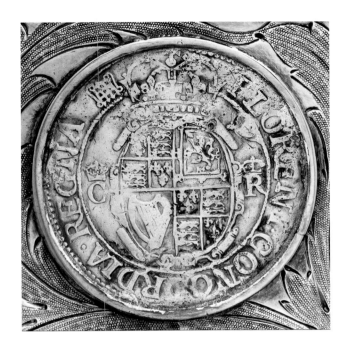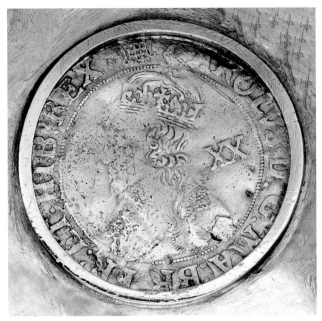

14

Unite of Charles I

Tower Mint, 1633–34
Gold
North 2153

Over the course of Charles I's reign before the outbreak of the First Civil War in 1642, gold coinage at the Tower Mint underwent a number of changes, particularly in the king's effigy. This unite was struck during a period of more simplified portraits in general (between 1626 and the late 1630s).[16] The crown Charles wears here is smaller than those he wears on other coins, and it is not jeweled (for a more legible portrait of Charles, see cat. 22). It also breaks the inner circle around the image.

15

Crown of Charles I

19th century, copy of an original of
1644 from Oxford
Silver
North 2407

This is a nineteenth-century cast copy of an extremely rare coin, the 1644 crown from Oxford (see fig. 3.7). Numismatists believe that only about one hundred of the coins were ever struck, of which approximately eleven survive. The original type, struck at Oxford from Thomas Rawlins's dies, is far superior in quality to the other crowns struck there. Within the sequence of Oxford crowns, this variation stands out in appearance; it is medal-like in its detail and quality, making it the most famous coin from Oxford and arguably the most famous coin by Rawlins. While there are several giveaways that this specimen is not an original, one telltale clue is the shape of the X in "REX" on the obverse: rather than sharp and straight, the lines of the letter are rounded and curved.

The obverse shows a large, artfully rendered Charles I on horseback with the Oxford skyline visible between the horse's legs. The Latin abbreviation for Oxford, *Oxon*, can be read between the spires of the buildings, and the initial *R* (for Rawlins) appears by the horse's tail. The reverse reads, "RELIG · PROT · LEG / ANG · LIBER · PARL" (the religion of the Protestants, the laws of England, the liberty of Parliament), a reference to Charles's declaration at Wellington, Somerset, one of the first battles of the war (see cat. 18). It also has a value mark (*V*), the date, and another *Oxon* inscription. The outer inscription on the reverse, "EXVRGAT DEVS DISSIPENTVR INIMICI," taken from the Bible (Psalm 68:1), can be translated as "Let God arise and let his enemies be scattered."

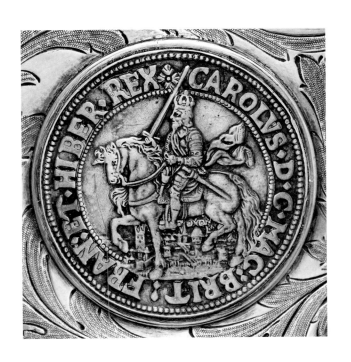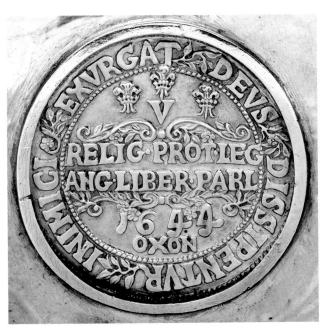

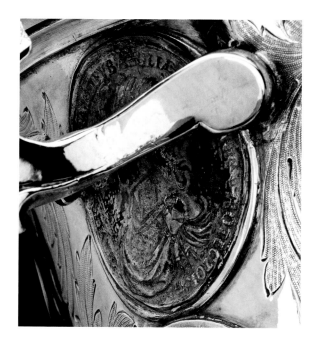

16

Medal of Oliver Cromwell (Lord Protector Medal)

1653

(Base?) silver

M.I.i. 409/45, Platt and Platt type B

This is one of two Lord Protector Medals on the Naseby Cup. Here, the medal was set to display the obverse on the cup's exterior, while the other medal (see cat. 20) exhibits the reverse. Commemorating Oliver Cromwell's elevation to Lord Protector of England, Ireland, and Scotland at the end of 1653, the original issue of the medal was struck in gold and silver and then cast in silver. Both examples on the cup appear to be cast; this one looks as if it may have lower silver content than the other.[17] On the reverse, an upright laureate lion sejant supports the shield of the Protectorate, which features an escutcheon with Cromwell's paternal coat of arms. The legend reads, "PAX · QVÆRITVR · BELLO ·" (Peace is sought by war).

17

Half Crown of Charles I

York, Yorkshire, England, 1643–44
Silver
North 2315

The Royalist mint at York was active from 1642 until the Battle of Marston Moor in Yorkshire on July 2, 1644.[18] The York mint produced high-quality silver coins—possibly the finest in appearance of all coins produced by the Royalists—using a cylinder press with dies made by Nicolas Briot.[19] Briot was actively involved with the York mint, and his correspondence indicates that its experienced staff may have come from Edinburgh, where he had been Master of the Scottish Mint. The Latin abbreviation for York, *Ebor*, is visible beneath the horse on the obverse of this half crown. The lack of refinement in this coin, however, indicates that either David Ramage (one of Briot's pupils) or another engraver was responsible for the York mint's early products.[20]

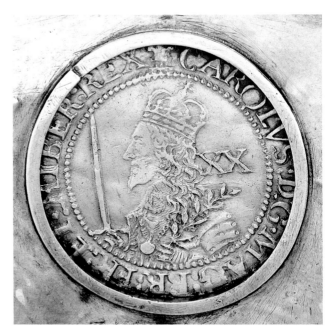

18

Unite of Charles I

Oxford, 1643
Gold
North 2389

Charles I delivered the Wellington Declaration on September 18, 1642, near Wellington, Somerset, shortly before the first battle of the Civil War. During the speech, he proclaimed he would uphold the Protestant religion, the laws of England, and the liberty of Parliament. A shortened Latin version of the declaration was presented on many of the coins struck under Charles during the war (see cat. 15). On this unite, it appears across three wavy lines or within an unfolded scroll: "RELIG : PROT / LEG : ANG / LIBER : PAR." The inscription around the shortened declaration, "EXVRGAT · DEVS · DISSIPENTVR · INIMICI:," is equally powerful. It means "Let God arise and let his enemies be scattered."

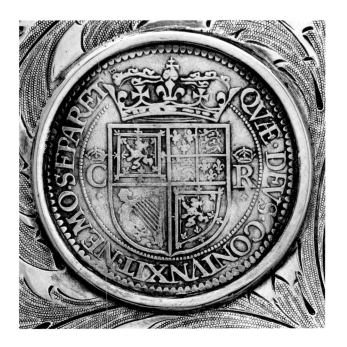
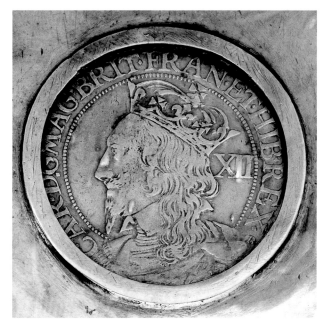

19

Twelve Shilling of Charles I

Edinburgh, 1637–41
Silver
Murray no. 19, Briot's third issue

When Nicolas Briot became Master of the Scottish Mint in 1635, he wanted to replace the traditional process of hammering coins with mechanical production. The king's Privy Council initially denied his proposal, but in 1636 it granted Briot a trial period to produce coinage using the "milne and presse." In October 1637, it ordered Briot and John Falconer, his son-in-law, to produce a coinage of thirty-shilling, twelve-shilling, half-merk, forty-penny, and twenty-penny pieces.[21] Most of Briot's coins have the initial *B* on both the obverse and reverse. On this coin, it can be found at the end of the reverse legend (at the top left near the edge of the crown) and at the end of the obverse legend (by Charles's shoulder). Lozenges appear frequently on Briot's coinage, and none of his coins are dated.[22]

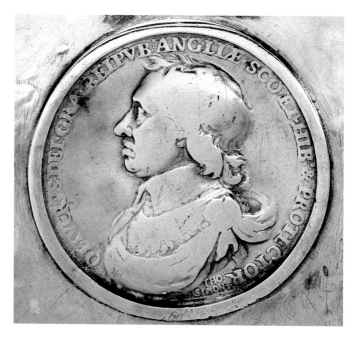

20

Medal of Oliver Cromwell (Lord Protector Medal)

1653

(Base?) silver

M.I.i. 409/45, Platt and Platt type B

Of the two Lord Protector Medals on the Naseby Cup (see cat. 16), this one was integrated to display the reverse on the cup's exterior, under one handle. The obverse shows the profile of Oliver Cromwell in armor wearing a scarf tied over his left shoulder. The inscription reads, "OLIVERVS · DEI · GRA: REIPVB: ANGLIÆ · SCO · ET · HIB: & · PROTECTOR" (Oliver, by the grace of God, Protector of the Republic of England, Scotland, and Ireland). Below Cromwell's shoulder is the engraver Thomas Simon's signature, "THO: SIMON · F."

21

Double Crown of the Commonwealth

Tower Mint, 1652
Gold
North 2717

The English shield is encircled by laurel and palm branches on the obverse of this double crown, with the mintmark of the sun at the top. The legend—notably in English, not Latin—reads, "· THE · COMMONWEALTH · OF · ENGLAND ·." On the reverse, the English and Irish shields appear side by side below the value mark (an *X*, for ten shillings), all within a beaded circle. The English legend reads, "GOD · WITH · VS ·," followed by the year. It is clear that the coin was hand struck (hammered): several letters and numbers have a "shadow" or "ghost," the result of a double strike (in which the die shifts slightly under the pressure of the hammer while being struck). This is especially evident in the word "of" and in the last few letters of "Commonwealth."

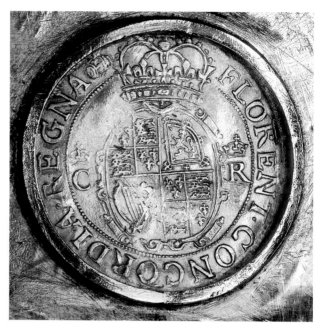

22

Unite of Charles I

Tower Mint, 1636–38
Gold
North 2153

This is one of several unites of Charles I on the Naseby Cup, and it is the same type as the unite illustrated in catalogue number 14. Since the two coins were produced in different years, they have different privy marks (see fig. 3.5)—a tun (seen directly above the king's crown on the obverse and just to the left of his crown on the reverse of this coin) versus a portcullis. The obverse of this unite, displayed on the cup's exterior, is better preserved than that of the other specimen, despite showing signs of a double strike. In addition, there are some very minor differences between the two portraits.[23] The most easily discernible difference is in the cross atop the crown: on this piece, the cross does not intersect the inner circle with the legend, whereas on the other unite it does.

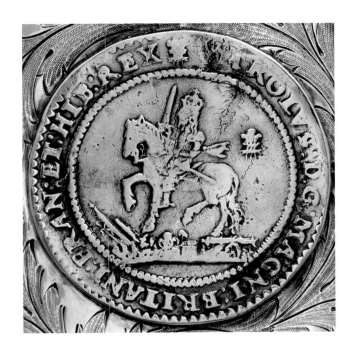
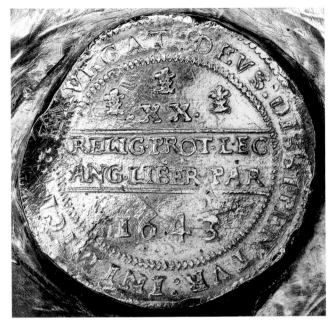

23

Pound of Charles I

Oxford, 1643
Silver
North 2398

All Oxford pounds have a portrait of Charles I on horseback on the obverse and a shortened Latin version of the Wellington Declaration on the reverse (see cats. 15 and 18). The equestrian portrait on this example is smaller than it is on most other pound types issued at Oxford. Below the horse are weaponry and a cannon. Interestingly, the final digit in the year (on the reverse, below the declaration) has been altered from a 2 to a 3. The numeral 3 on other Oxford pounds has a far straighter top line than the one here. Die studies have confirmed that some 1642 reverse dies were altered to change only the last numeral of the date.[24]

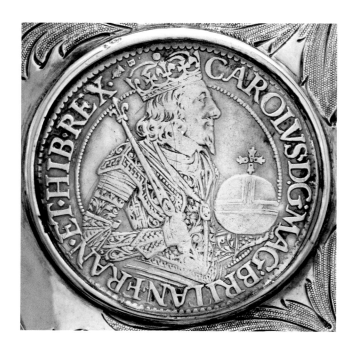
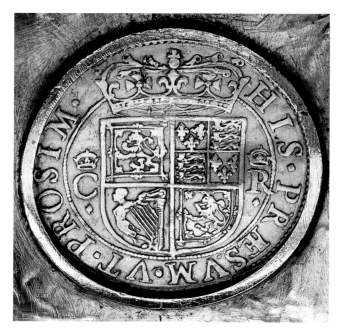

24

Unite of Charles I

Edinburgh, 1637–41
Gold
Murray no. 2, Briot's third issue

The crown that Charles I wears on the obverse of this coin is the Scottish crown, setting it apart from the crowns depicted on many of the other coins integrated into the cup. Of the two types produced for the third issue of the unite, this one is more common. The difference between the two is the placement of Nicolas Briot's initial mark. On this type, the *B* appears with a thistle head at the end of the obverse legend, while on the rarer type it appears at the beginning.[25] None of Briot's Scottish gold coinage has a value mark.

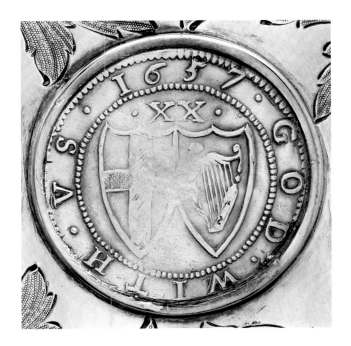 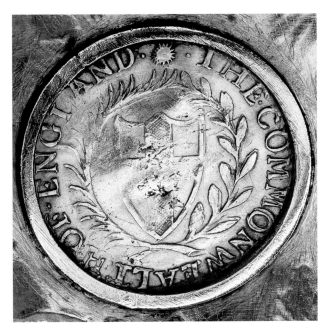

25

Unite of the Commonwealth

Tower Mint, 1657

Gold

North 2715

This is the only unite of the Commonwealth that appears on the cup. The sun mintmark (visible at the end of the legend on the obverse) was used by the Commonwealth from 1649 to 1657.

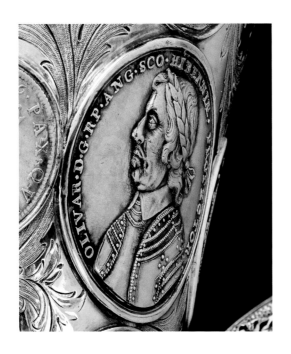
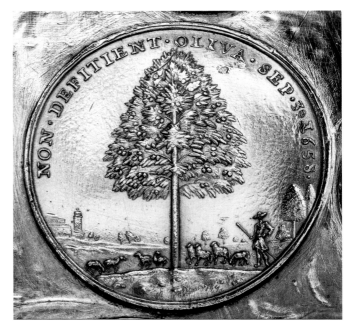

26

Medal of Oliver Cromwell ("Funeral" and Memorial Medal)

The Netherlands, 1658
Silver
M.I.i. 435/85, Platt and Platt type C

This medal is a struck imitation of a work by Thomas Simon, who was appointed chief engraver of the Tower Mint by Lord Protector Oliver Cromwell in 1656. Copies of Simon's medal were made to supply collectors who were unable to obtain the valuable original. The differences among the original types—changes in Cromwell's clothing, the legend, and the size—are subtle. Medals of the original type (A) would have been furnished with a loop and ring, enabling them to be worn by Cromwell's friends and partisans. This type (C) appears in both silver and, more scarcely, gold. The obverse has a portrait of Cromwell (see cat. 32), and the reverse shows a young olive tree, near which a shepherd tends his flock, with buildings and other trees in the distance. The legend, "NON · DEFITIENT · OLIVA · SEP · 3 · 1658," meaning "They shall not lack an olive tree," with the date of Cromwell's death, alludes to Cromwell's son, Richard, who succeeded him as Lord Protector.[26]

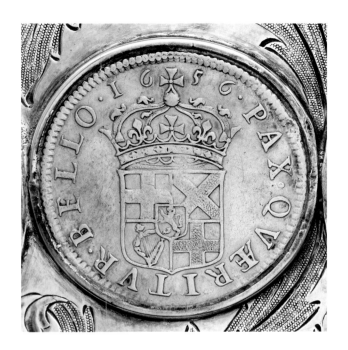 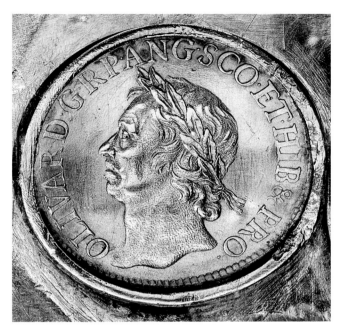

27

Pattern Broad of Oliver Cromwell

Drury House, London, 1656

Gold

North 2744

This coin is classified as a pattern, since the portrait coins of Oliver Cromwell were not tested at the Trial of the Pyx and were never legalized for circulation. Nevertheless, many of these patterns were in circulation and use. Due to their rarity and beauty, people also hoarded them as souvenirs or sold them at a premium. The patterns were not mentioned in the 1661 proclamation that demanded that coinage issued by the Commonwealth be withdrawn from circulation.

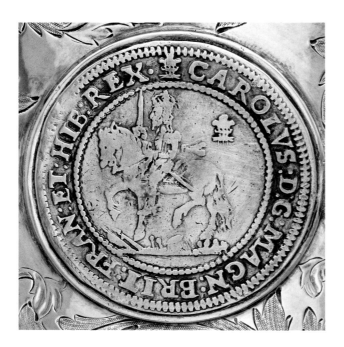
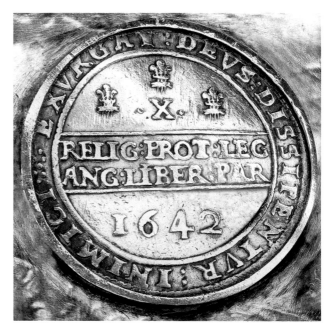

28

Half Pound of Charles I

Oxford, 1642

Silver

North 2404

The half pound from Oxford is similar to the pound from Oxford (see cat. 23); the main difference is in the value mark—*X* for a half pound, *XX* for a pound. While half pounds (and some pounds) are the same diameter as crowns, the pound and half pound were struck on thicker flans.

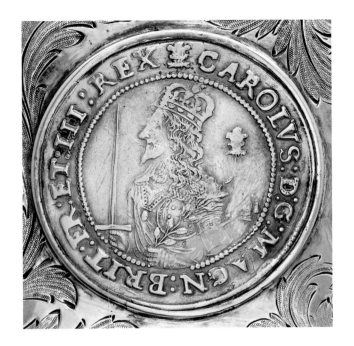
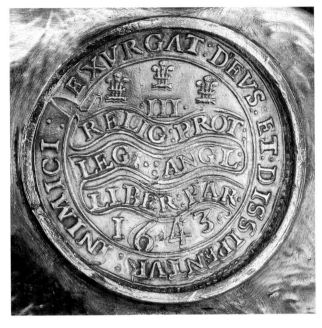

29

Triple Unite of Charles I

Oxford, 1643

Gold

North 2382

As England's largest hammered gold coin, the triple unite (sixty shillings) accommodated bigger, more detailed designs. Thus, the king's portrait on the triple unite is more elegant and lifelike than his image on most other coins and includes various symbolic details. Here, Charles I holds a sword in his right hand, ready to fight for his cause; in his left hand, he holds an olive branch, demonstrating his proclivity toward a peaceful resolution (the sword and olive branch also appear in the Medal of Peace or War; see fig. 2.4). There are two types of this coin, one with a long olive branch, the other with a short olive branch. The type in this example, with the long branch, is the rarer of the two. The reverse of the coin references the Wellington Declaration (see cats. 15, 18, and 23).

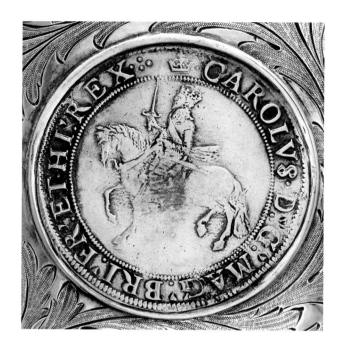
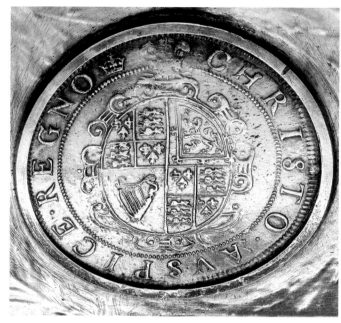

30

Crown of Charles I

Tower Mint, 1635–36
Silver
North 2196

The obverse of this silver crown shows Charles I riding on horseback. It is the third of five equestrian portrait types. The king wears a lace ruff collar and holds a sword. The legend is the one typically used for coinage produced under Charles, and the privy mark (located at the top, at the start of the legend) is a crown, which dates the coin to 1635–36 (see fig. 3.5).

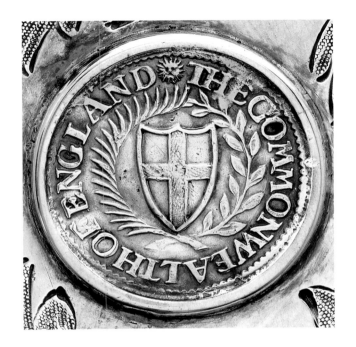

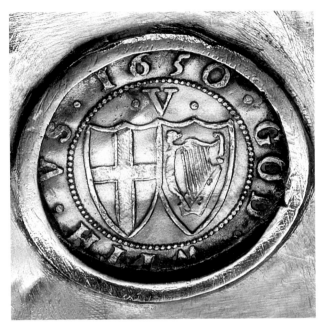

31

Crown of the Commonwealth

Tower Mint, 1650

Gold

North 2719

Before the English Civil War, the Tower Mint changed the privy mark (also known as the initial mark or mintmark) on its coins roughly annually, as a measure for ensuring quality. After Parliament took control of the Mint in 1649, it changed the privy mark less frequently. The mark on this coin, the sun, was used by the Commonwealth from 1649 to 1657. Yet the year is included on the reverse of this coin, making it possible to precisely determine its date.

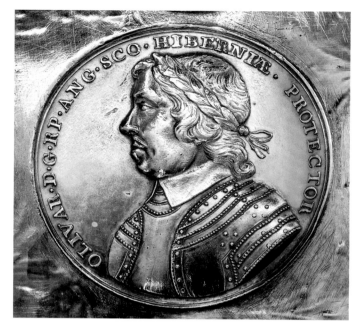

32

Medal of Oliver Cromwell ("Funeral" and Memorial Medal)

The Netherlands, 1658
Silver
M.I.i. 435/85, Platt and Platt type C

This medal is a copy of the original "Funeral" and Memorial Medal of Oliver Cromwell by Thomas Simon. Unlike the other example on the Naseby Cup (see cat. 26), which is integrated to display the obverse of the medal on the cup's exterior, this one displays the reverse on the exterior. The obverse depicts Cromwell with a laurel crown and long hair, wearing a plain falling collar and armor, with the legend "OLIVAR · D · G · RP · ANG · SCO · HIBERNIÆ · PROTECTOR" (Oliver, by the grace of God, Protector of the Republic of England, Scotland, and Ireland).[27]

33

Twelve Shilling of Charles I

Edinburgh, 1637–41

Silver

Murray no. 21, Falconer's first issue
with *F*

John Falconer's first issue can easily be distinguished from his later coinage by two details: the bust of Charles I (seen on the obverse of this twelve shilling) extends nearly to the edge of the coin, and the legend begins at the lower left (at 7 o'clock) as opposed to the top of the coin. On this twelve shilling, Falconer's initial, *F*, appears on the reverse, sideways at the top, above the crown. Numismatists believe that only a single pair of dies was used to produce the twelve-shilling pieces, indicating a limited production run.[28]

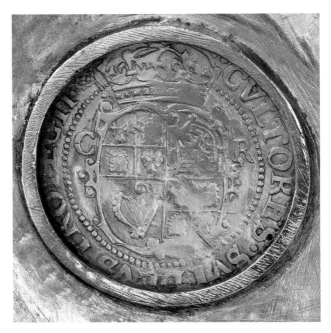

34

Double Crown of Charles I

Tower Mint, 1631–32
Gold
North 2166

This double crown shows traces of uneven striking or a worn die. Most of the coin is well preserved: both the obverse and reverse legends are crisp and legible, both the inner and outer circles on the obverse are intact, and the inner circle on the reverse is nearly immaculate. The image on the reverse is relatively clear, but the right half has less definition. The obverse portrait, however, has obvious defects. While Charles I's bust is well struck and well preserved, all that is left of his face is a vague outline of his profile.

35

Medal of Gaston, Duc d'Orléans

1660

Silver

Jones II, 278

Jean Hardy produced this medal after the death of Gaston, Duc d'Orléans, a brother of King Louis XIII of France, on February 2, 1660. Gaston was considered a connoisseur of medals and was known throughout Europe for his knowledge of *medailles anciennes*.[29] Although this medal may at first seem out of place on the Naseby Cup, as it shows no direct connection to the English Civil War, Gaston was, in fact, Queen Henrietta Maria's uncle. Gaston's constant conspiring against Cardinal Richelieu, who sought to centralize power in France, is somewhat evocative of the behavior of John Lilburne (see cat. 9) and the general tensions of the English Civil War.

36

Pattern Half Crown of Oliver Cromwell

Drury House, London, 1658
Silver
North 2746

Placed beneath the handle of the cup, this pattern is partly obscured. There is another example elsewhere on the cup that can be seen more clearly (see cat. 49). Of the two, however, this is the better-preserved specimen.

37

Shilling of Charles I

Tower Mint, 1628–29 or 1638–39
Silver
North 2228–2230/2231

It is difficult to determine the date and type of this coin because of its condition and placement within the frame made for integrating it into the cup. The privy mark appears to be an anchor, which the Tower Mint used twice, first in 1628–29 and then again in 1638–39 (see fig. 3.5). The other feature used to determine the date and type, Charles I's portrait, is obscured due to an overstrike (in which the obverse of a coin was overstruck by the reverse die). At first, it looks like the reverse die (with the image of the escutcheon) overstruck the obverse (the portrait). However, this was actually a flip overstrike during the minting process, in which the obverse overstruck the reverse. The first and fourth quadrants of the escutcheon on the obverse are visible, and the outline of the third is faint, all tilted to the right. In addition, on the reverse there is an unusual semicircular curve, from the top left toward the escutcheon. This may be further evidence of the bizarre mint error.

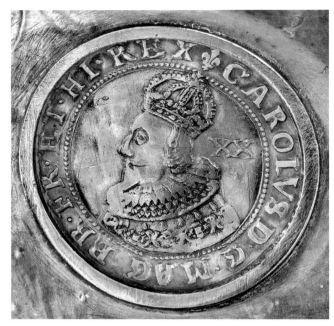

38

Unite of Charles I

Tower Mint, 1625
Gold
North 2147

This coin was struck in the year of Charles I's accession to the throne, making it a notable inclusion on the Naseby Cup. The obverse shows the first portrait type of Charles's coinage, which is strikingly different from portraits on later unites from the Tower Mint (see cats. 14 and 22). On this coin, the king wears a double-arched crown and his attire is different; most notably, he wears a ruff collar. This unite has been double struck, like some of the other coins on the cup.

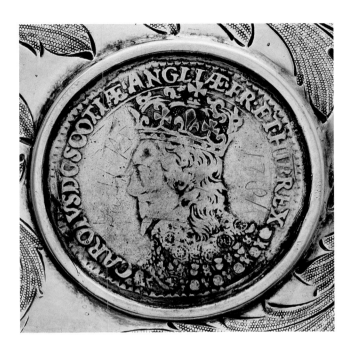
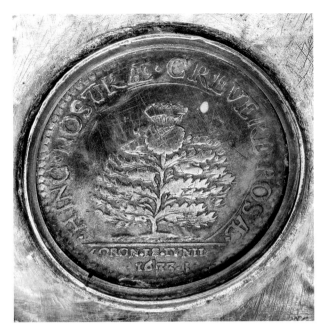

39

Medal of Charles I

Edinburgh, 1633
Silver
M.I.i. 266/60, Platt and Platt type B

This medal was produced to celebrate Charles I's Scottish coronation in Edinburgh in 1633. There are four known types, all of which have an obverse with a bust of Charles facing left, with long hair, a crown, a falling lace collar, ermine robes, and collars of the Orders of the Garter and Thistle.[30] The reverse has a combined thistle plant and rose tree—symbols of Scotland and England, respectively—representing the closeness of the two countries. Although the edge of the medal cannot be read due to its integration into the cup, it might have had an inscription indicating that Nicolas Briot was responsible for its production (only some of the silver medals of this type have this edge inscription). It is said that Charles liked the medal so much that he carried a gold version in his pocket, only three of which were minted.[31]

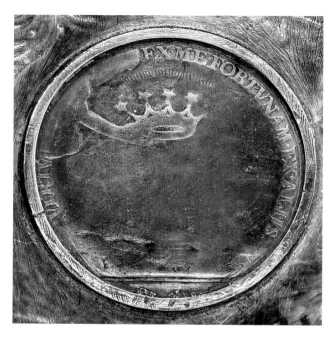

40

Medal of Charles I

1670

Silver

M.I.i. 347/201, Platt and Platt type C

This medal, produced after the Restoration in 1660, is a copy of a large hand-struck memorial medal that the Flemish medalist Norbert Roettiers made in 1649 after the death of Charles I. Between the original and later types of this medal, there are only minor differences in the obverse, most notably regarding the initial of Rottiers, which is only included in the original type (A) and in one specimen of a later type (B). The most significant difference is on the reverse; whereas the original has an inscription of six lines, this was replaced in later types with a pastoral scene. Above a field with grazing sheep (partially worn in this example), a hand holding a celestial crown extends from heaven. The legend reads, "VIRTVT · EX · ME · FORTVNAM · EX · ALIJS ·" (Seek virtue from me, fortune from others).[32]

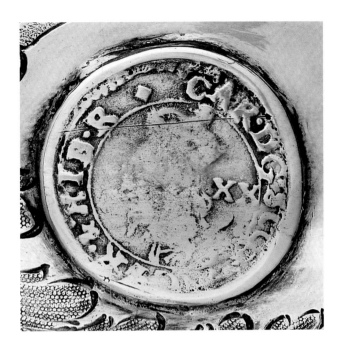 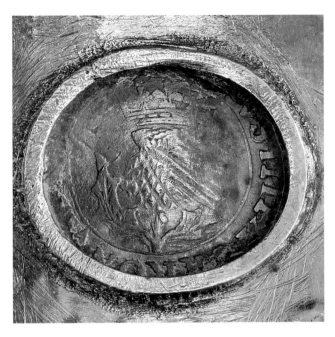

41

Twenty Pence of Charles I

Edinburgh, 1637–41
Silver
Murray no. 42(?), Falconer's
second issue

The unifying feature on all of John Falconer's coins (three of which appear on the Naseby Cup; see also cats. 33 and 43) is their reliance on Nicolas Briot's initial work as the mintmaster at Edinburgh. Falconer used Briot's machinery and his punches to create dies. Falconer's dies, however, were poorly executed; furthermore, on many of his coins (though not any on the cup), the legends were struck off flan.[33]

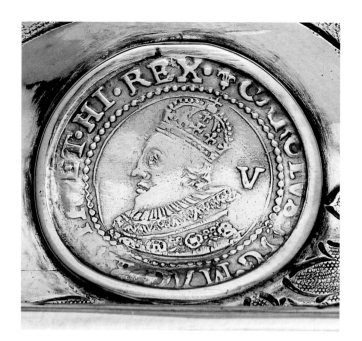
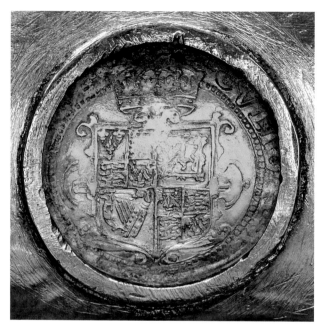

42

Crown of Charles I

Tower Mint, 1630–31

Gold

North 2182

This crown exhibits scars of the work that the silversmiths Charles Reily and George Storer undertook to integrate the numismatic objects into the Naseby Cup. The reverse shows some of the most visible evidence of the soldering they used to securely fix the coins' frames into the vessel—much of it has been defaced by sweating during the process. The obverse attests to the difficulty Reily and Storer faced in shaping the pieces to match the curvature of the cup. On this crown, it resulted in an uneven fold of the coin at the bottom, below the portrait bust. From a distance, this is less noticeable, and the contour of the cup is maintained.

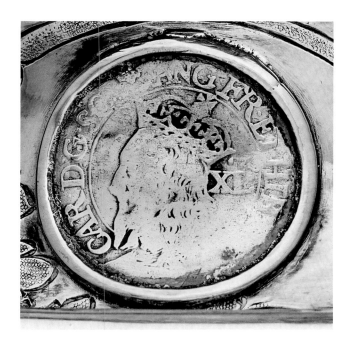

43

Forty Pence of Charles I

Edinburgh, 1637–41
Silver
Murray no. 35, Falconer's first issue
with *F*

Toward the end of Charles's reign, the Privy Council banned the circulation of foreign silver in Scotland. To compensate, the Scottish mint produced large quantities (by Scottish standards) of forty- and twenty-pence coins (see cat. 41). While this may have partially eased the short supply of small change, the newly produced coins flowed out of Scotland, so the shortage remained a problem.[34] The obverse of this forty-pence piece shows crowned Charles I with the value mark *XL*. The reverse is heavily worn and almost illegible, possibly as a result of the work undertaken to solder and integrate the coin into the cup (as evidenced by the scratches).

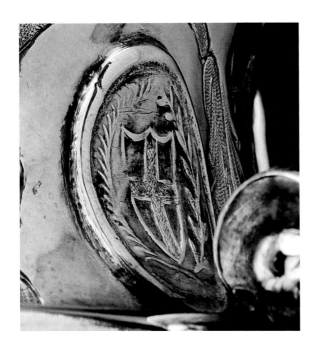
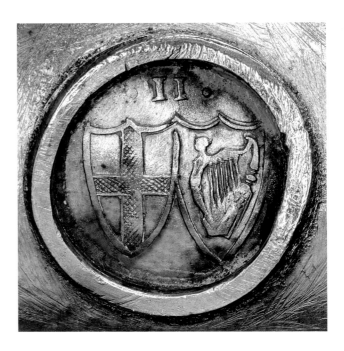

44

Half Groat of the Commonwealth

Tower Mint, 1649–60
Silver
North 2728

Given its relatively low value of twopence, the half groat would have been used for daily transactions, much like other low-value denominations. In London a person might have used a half groat to purchase their daily bread and beer.

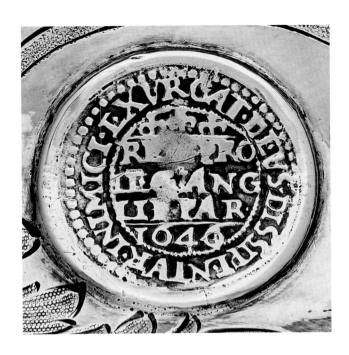 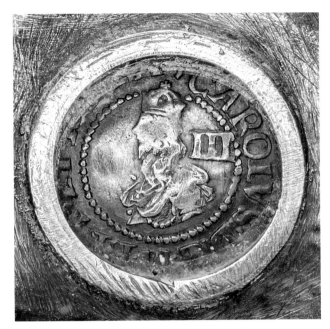

45

Threepence of Charles I

Oxford, 1646
Silver
North 2473

On this very small coin, a shortened reference to the Wellington Declaration by Charles I (see cats. 15, 18, 23, and 29) appears between two parallel lines: "RELI · PRO / LEG : ANG / LIB · PAR ·." It is encircled by the legend "EXVRGAT · DEVS · DISSIPENTVR · INIMICI ·" (note the use of an inverted *A* for the *V*s). The last digit of the year 1646 was engraved over the final *4* in 1644; the original *4* is visible underneath and protruding beyond the *6*.

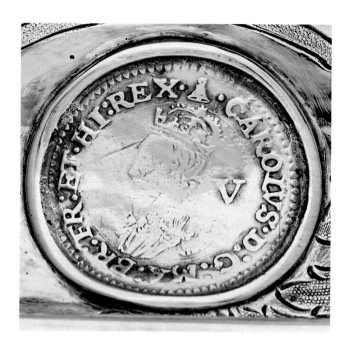
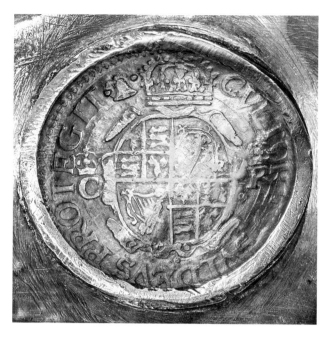

46

Crown of Charles I

Tower Mint, 1634–35

Gold

North 2185

This gold crown of Charles I is similar to the other Tower Mint gold crown on the cup (see cat. 42), but it has a different portrait bust on the obverse and a different shield on the reverse. Although the bust is faint, the legends are crisp and legible, signaling that the coin itself is not worn down. Rather, the bust must have been punched from a weak hub.

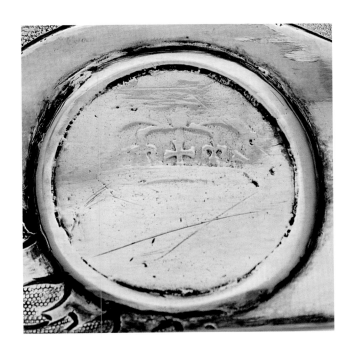
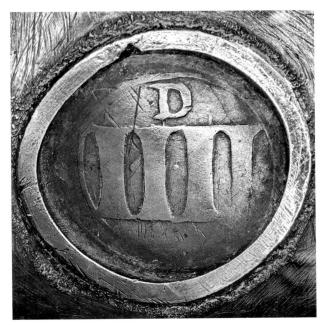

Body of the Cup Fourth Row

47

Groat of Charles I

Ireland, 1643–44
Silver
Ormond money

The Irish Rebellion of October 1641 led to the formation of the Irish Catholic Confederation. It prompted the creation of a series of coins by both the insurgent Catholics in Kilkenny and the Royalists in Dublin, who appealed to England for troops and money but also struck their own coinages of necessity. On July 8, 1643, they received royal permission to coin crowns, half crowns, shillings, sixpence, and lesser values, as long as they were the correct English standard.[35] The obverse of all the coins displayed the initials *CR*, for "Carolus Rex," with a crown, and the reverse had the value mark (in this case, *IIII* instead of the customary Roman numeral *IV*). This coinage is commonly referred to as "Ormond money," after James Butler, Marquis of Ormond, who was lieutenant-general of Charles I's forces in Ireland and later lord-lieutenant.[36]

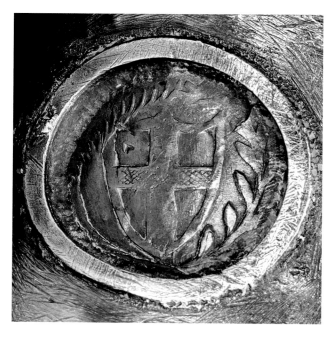

48

Half Groat of the Commonwealth

Tower Mint, 1649–60
Silver
North 2728

Unlike some of the other Commonwealth coins, the half groat does not have an obverse legend, a reverse legend, or a date. It also does not have a privy mark, so the specific date of the coin cannot be determined.

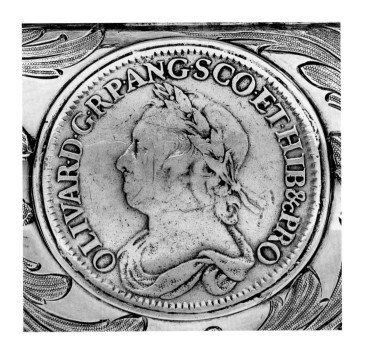
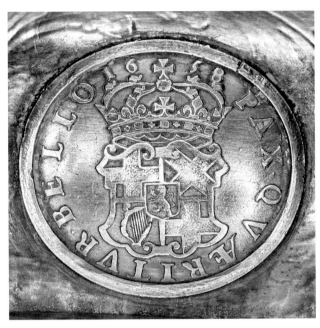

49

**Pattern Half Crown of
Oliver Cromwell**

Drury House, London, 1658

Silver

North 2746

The half crown was valued at two shillings and sixpence; however, the patterns of Oliver Cromwell were never approved, and so the half crowns with his portrait were never considered legal money. The same pattern denomination appears elsewhere on the cup (see cat. 36), and both examples were integrated to display the obverse on the cup's exterior.

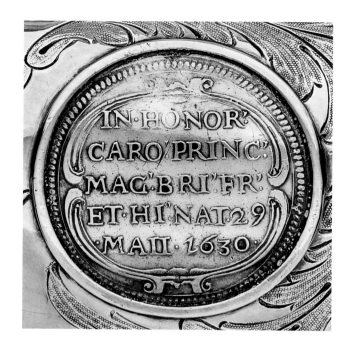

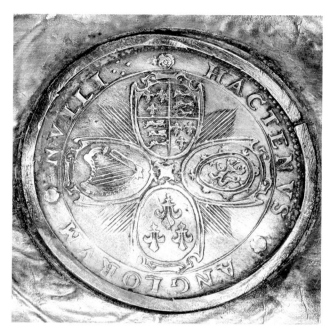

50

Medal of the Birth of Prince Charles (Charles II)

The Netherlands, 1630

Silver

M.I.i. 254/35, Platt and Platt type B

This medal was made to celebrate the birth of Prince Charles (later King Charles II). On the obverse, facing the interior of the cup, are the shields of four kingdoms with rays emanating from the center—which may allude to the appearance of the planet Venus at the exact time that King Charles I left Saint Paul's Cathedral in London after the thanksgiving service. The shield at the top, near the mintmark, is a combination of the shields of France and England; the others, moving clockwise, are the shields of Scotland, France, and Ireland. The legend reads, "HACTENVS ⁂ ANGLORVM ⁂ NVLLI •" (Hitherto to none of the English). The reverse consists of a square tablet with the legend "IN · HONOR' · CARO' · PRINC' · MAG' · BRI' · FR' · ET · HI' · NAT · 29 · MAII' · 1630 ·" (In honor of Charles, Prince of Great Britain, France, and Ireland, born 29 May 1630). Multiple dies with slight variations, particularly in the decorative stops between words, were used in the production of the medal.[37]

51

Crown of Charles I

Ireland, 1643–44
Silver
Ormond money

This crown is another example of "Ormond money," coinages of necessity produced in Ireland during the early years of the First Civil War. It is a higher denomination than the Ormond groat (see cat. 47), as indicated by the value mark on the reverse (*V*). Both denominations have the same design on the obverse, which is better preserved on the crown. Part of the beaded outer circle here has remained intact. Since Ormond money was struck from silver plate, occasionally the original pattern of the plate can be discerned beneath the impressed coin design.

52

Shilling of Charles I

Tower Mint, 1634–35
Silver
North 2225

On this shilling, the portrait of Charles I is only identifiable by a vague outline. This is a dramatic example of the result of a worn die (similar to the double crown of Charles I; see cat. 34). While the legend is crisp and legible, and the back of Charles's head and crown are well struck, the front half of the portrait is indistinct. This kind of wear pattern is typical of hammer-struck coinage and indicates the use of an obverse die in a later stage of its utility.

53

Shilling of the Commonwealth

Tower Mint, 1652

Silver

North 2724

This shilling of the Commonwealth dates to the same year as the New England shilling from Boston (see cat. 58), the first coinage struck in the British colonies in North America. The two coins are the same value (twelve pence) but would not have circulated together.

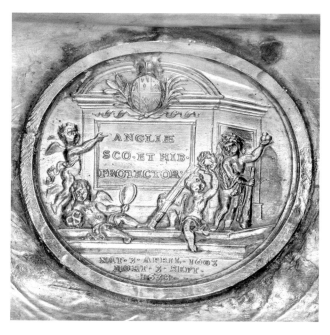

54

Medal of Oliver Cromwell

1731
Silver
M.I.i. 435/87, Platt and Platt type A

The Swiss engraver Jean Dassier struck this medal in 1731 as part of a set of thirty-four medals titled *The Kings and Queens of England*. The original presentation sets (only a few of which were made) consisted of thirty-three medals, from William the Conqueror (r. 1066–87) to King George II (r. 1727–60). When George II received a set, he asked that his wife, Caroline, be added to it. Thereafter, the set of thirty-four medals was available for sale in England.[38] Oliver Cromwell's medal is three millimeters smaller than those of the other rulers in the set, and two types of the medal were struck.[39] Interestingly, the date on the reverse is incorrect: Cromwell was born on April 25, 1599, not April 3, 1603.

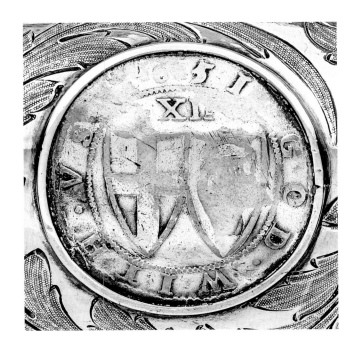

55

**Shilling of the
Commonwealth**

Tower Mint, 1651

Silver

North 2724

Both of the dies used for this shilling were worn by the time the coin was produced. On the obverse, which faces the interior of the cup, the central motif is faint, while parts of the legend are still crisp and in high relief. A similar effect occurs on the reverse. The Irish harp, on the right, has lost all of its detail, and the *16* in the date (1651) has almost no definition.

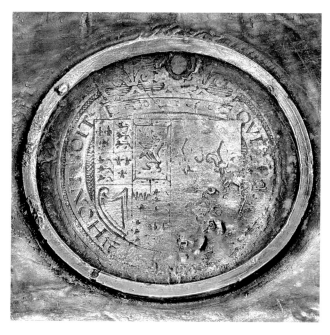

56

Counter of Charles I

ca. 1630

Silver

M.I.i. 378/277

This is a counter that was stamped to make it look like it was engraved. It may have been part of a set used for reckoning and play. The piece is unsigned, but it may have been made by the Dutch engraver Simon de Passe or by someone from his school (see cats. 65 and 69 for other counters in a similar style). The obverse shows the busts of Charles I and, slightly behind him, Henrietta Maria, while the reverse presents the conjoined crowned shields of England and France within a wreath. In addition to having clear traces of use, the counter was also holed, presumably before it was added to the cup (note the circular plug at the same location on the obverse and reverse).

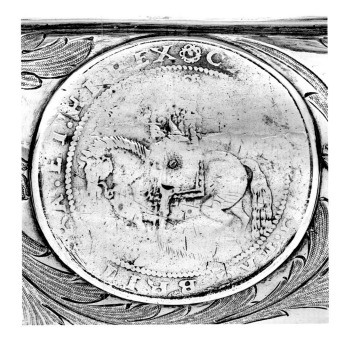
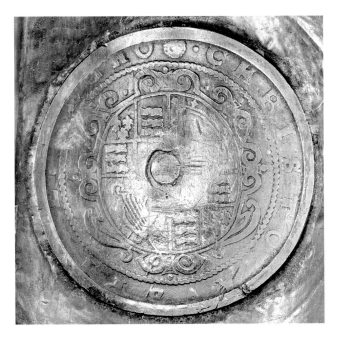

57

Crown of Charles I

Truro, Cornwall, England, 1642–43
Silver
North 2531

This is the only coin on the Naseby Cup from the Royalist mint at Truro, Cornwall, and it is rather uncommon. On November 14, 1642, shortly after the start of the war, Sir Richard Vyvyan was commissioned to coin silver and gold bullion after the current Tower Mint pattern and to deliver the proceeds to the Royalist commander at Cornwall. The commission did not list a location for Vyvyan's project, and by January 1643 he was accepting plate to turn into coin at the important seaport town of Truro. The bulk of the coinage was crowns and half crowns, suitable for soldiers' pay, as well as some shillings. All of the coins from Truro bear a rose as a privy mark.[40]

58

Shilling of New England

Boston, 1652

Silver

Noe type II-A

The presence on the Naseby Cup of a New England shilling—easily the most far-fetched coin on the cup—may at first seem rather bizarre. While coins struck in England, Ireland, and Scotland have a clear connection to the English Civil War, the connection to a coin from New England is perhaps less obvious. The shilling may have been incorporated as a reference to the war's impact beyond the British Isles. Most of the English colonists in America had departed England only a decade or so at most before the outbreak of the war. Not only were they still dependent on England for their survival, but they were also still in the process of establishing their own institutions, confronting many of the same economic, political, religious, and social issues as their English counterparts.[41]

It is also possible that the coin was included for its political significance. During the war, both Charles I and Parliament encouraged increased self-government in the North American colonies, in an effort to win their support. The colonists welcomed the opportunity to strengthen their case for the right to a representative government, and ultimately the Massachusetts Bay Colony decided to produce its own coinage.[42] The Commonwealth's descent into a dictatorial Protectorate under Oliver Cromwell heightened the colonists' desire for self-autonomy and further increased their coinage efforts. Although there was no prohibition against the export of Massachusetts silver coins until 1654, only a handful of the early coins ended up in England.[43] The condition of this shilling indicates that it probably did not circulate long, so it may have been selected specifically for the cup due to its historical significance.

As a product of the Massachusetts Bay Colony, the New England shilling also had relevant religious connotations. The colony was settled by Puritans, many of whom backed their Puritan brethren in the British Isles against Charles I. The pastor Hugh Peter in Salem, for example, returned to England in 1641 as an agent for Massachusetts and became chaplain to Cromwell's New Model Army. Given Cromwell's own Puritan background, the inclusion of the shilling on the cup may have commemorated some colonists' support of the Parliamentarian cause.[44]

The precise reason for the shilling's inclusion on the cup and the circumstances of its arrival in England may never be known. Yet it is clear that, despite being geographically distanced from the battles across the Atlantic, the colonies were similarly entrenched in the turmoil.

59

Half Crown of the Commonwealth

Tower Mint, 1656

Silver

North 2722

While the other half crowns on the cup (see cats. 17, 36, and 49) do not have a value mark, this coin does: its Roman numerals indicate two shillings and sixpence (see fig. 3.4). The half crown produced as siege coinage at Newark (see cat. 62) also has a value mark, although it is expressed differently.

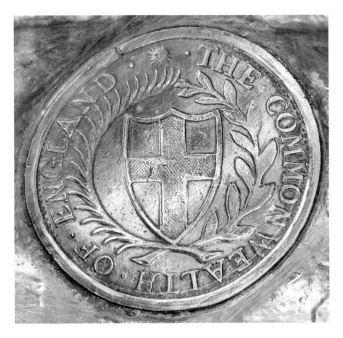

60

Crown of the Commonwealth

Tower Mint, 1652
Silver
North 2721

On the reverse of this crown, at the top by the date, the outer circle appears to have been slightly amended to make room for the numerals 52 in the year (1652). This is most apparent above the 5. In addition, the placement of the year is off: the space between the 6 and 5 should be centered at the top of the coin; instead, the date has been shifted counterclockwise, so that the 5 is at the top. Moreover, the value mark, *V*, is tilted to the right. All of these irregularities suggest that the reverse die used to strike this coin must have been poorly executed.[45]

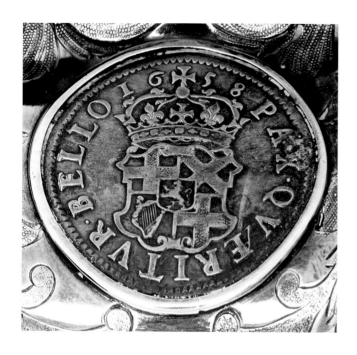

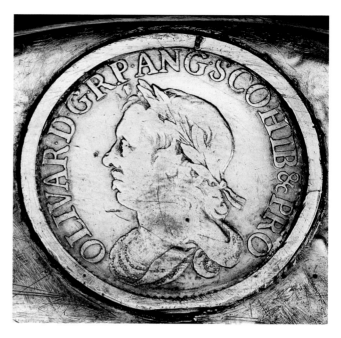

61

Pattern Sixpence of Oliver Cromwell

Drury House, London, 1658
Silver
North 2748

This pattern sixpence of Oliver Cromwell, one of two on the Naseby Cup (see cat. 63), was integrated to display the reverse on the cup's exterior. Struck in the year of his death, Cromwell's portrait coins were meant to replace the hammered coinage that was circulating at the time, but were never properly issued. Instead, people retained them as souvenirs. Both of the pattern sixpences on the cup have been extremely misshaped to conform to the contours of the overall object.

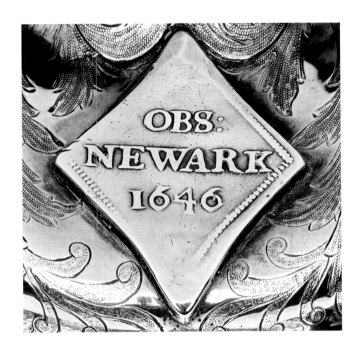

62

Half Crown of Charles I

Newark, Nottinghamshire,
England, 1646
Silver
North 2638

This half crown from Newark is similar to the shilling from Newark positioned on the opposite side of the cup (see cat. 64). The reverse (on the exterior of the cup) is inscribed "OBS: / NEWARK / 1646." The letters *OBS*, short for the Latin *obsidium* (siege), also appear on coins produced by other besieged cities, followed by the name of the city or an abbreviated version of it, such as "CARL" (Carlisle), "COL" (Colchester), or "P" (Pontefract). Most half crowns do not have a value mark; on those that do, the mark is typically *II VI* (two shillings and sixpence; see cat. 59). The mark on this coin, however, is *XXX*. Both marks denote the same value, thirty pence.

63

Pattern Sixpence of Oliver Cromwell

Drury House, London, 1658
Silver
North 2748

This pattern was positioned on the cup to appear opposite the other pattern sixpence of Oliver Cromwell (see cat. 61). Instead of displaying the reverse on the cup's exterior, however, this coin displays the obverse. The viewer can therefore see both sides of the pattern without having to look inside the cup.

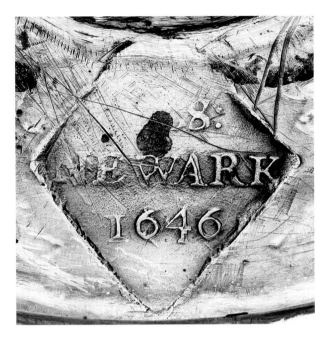

64

Shilling of Charles I

Newark, Nottinghamshire,
England, 1646
Silver
North 2640

Newark was besieged several times during the Civil War, partly because its location made it an ideal strategic center for communications and afforded an open supply route between Oxford and York. Situated in eastern England, it also served as a base from which Royalists could raid local Parliamentarian lands. Coins, however, were only produced in Newark during the final siege of the city, from November 26, 1645, to May 8, 1646. All of the denominations produced there (half crown, shilling, ninepence, and sixpence) are dated either 1645 or 1646 and have the same lozenge shape. The sole difference among them is the value mark, seen on the obverse of this shilling. A large number of coins from Newark have survived, perhaps as prized souvenirs—many were pierced to attach to or hang from something.[46]

65

Counter of James I

ca. 1616–25
Silver
M.I.i. 376/272

The obverse of this counter displays King James I, facing right, in three-quarter view, wearing a broad-brimmed hat with a jewel brooch, a lace ruff, ermine robes, and the collar of the Order of the Garter. There are several variations of the counter with different legends and portraits of his son Prince Charles (later King Charles I) at an older age with a beard on the reverse. On this piece, Charles's portrait (facing the interior of the cup) is pitted and obscured. In 1617 Nicholas Hilliard, the jeweler, goldsmith, and engraver to Elizabeth I and James I, received a patent granting him a twelve-year monopoly on all engraved portraits of the royal family. He sold the licenses to execute these counters to other engravers, primarily Simon de Passe (who likely created this piece) and de Passe's brother.

 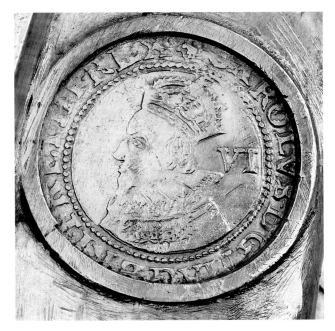

66

Sixpence of Charles I

Tower Mint, 1625

Silver

North 2235

Issued during Charles I's first year as king, this sixpence features the first bust type of Charles to appear on coinage (although here it appears in relatively low relief). There are some minor differences in the obverse legend among coins of this type, notably in the use of "BRI" or "BR" for Britain and "FRA" or "FR" for France; this piece has "BRI" and "FR."[47] The reverse is standard for all coins of this type: a plain square-topped shield over a long cross fourchée, below the date.

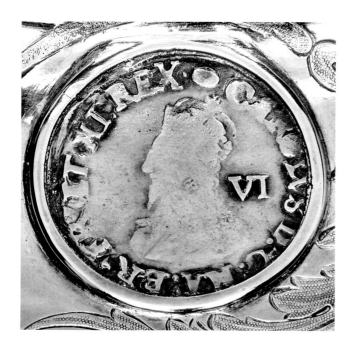 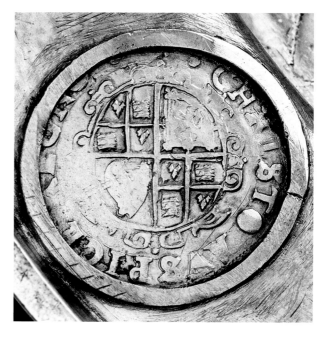

67

Sixpence of Charles I

Tower Mint, 1636–38
Silver
North 2241

Both sides of this sixpence display the result of uneven die wear. The obverse portrait shows the typical effects of a worn die, while certain letters lack definition, such as the letters *CARO* in "CAROLVS." The reverse die must have been less worn but was starting to show some of the same signs of deterioration. The central motif, for instance, is fading—the Irish harp has lost all of its detail—and much of "CHRISTO" in the legend is indistinct.

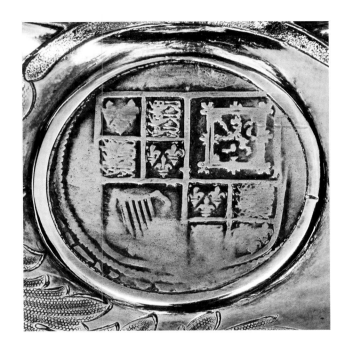

68

Shilling of James I

Tower Mint, 1604–5 or 1605–6
Silver
North 2099

This worn coin has been identified as a shilling of James I by the surviving vestiges of the portrait. Among James's silver coinages, there are six main portrait types, three of which show him with a prominent pointed beard. The portrait type with the most prominent beard, square and projecting outward from his chin, is visible in an outline on this shilling. The precise date of the coin's production, however, cannot be determined, since two privy marks (the fleur-de-lis and rose)—representing two different coin issues—were used together with this portrait type, and neither can be seen on this specimen.[48]

69

Counter of Charles I

ca. 1626–27
Silver
M.I.i. 377/275

On this counter of Charles I, the bust of Henrietta Maria appears on the reverse. The queen wears earrings, a pearl necklace, a deep lace collar, and a low bodice. On the obverse, Charles I is shown wearing a broad-brimmed hat similar to the one worn by James I in another counter on the cup (see cat. 65). Many of the fine details of this piece are worn away, suggesting heavy use.

 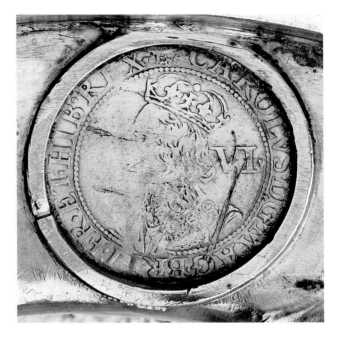

70

Sixpence of Charles I

Tower Mint, 1638–39
Silver
North 2306, Briot's second
milled issue

This is one of Nicolas Briot's limited milled issues at the Tower Mint. Another milled sixpence by Briot is directly adjacent to this one on the cup (see cat. 71). The sixpence here has a double privy mark on the obverse, an anchor with a mullet (which is not repeated on the reverse, as was customary). The reverse does not display the typical definition and sharpness of a milled coin; this is especially apparent when contrasted with the reverse of the adjacent sixpence. Its smooth, polished appearance may be a result of a combination of events, including wear during circulation, postcirculation treatment, and the shaping of the coin to fit the cup. While the interior-facing sides of both sixpences have retained much of their sharp detail, the exterior-facing sides have not, demonstrating the detrimental impact of polishing on coins—a practice that was common among later collectors.

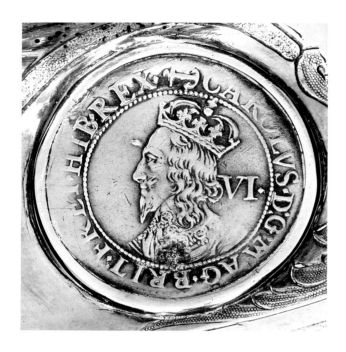
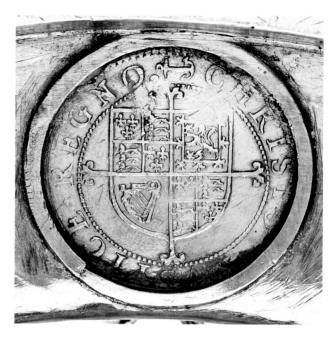

71

Sixpence of Charles I

Tower Mint, 1638–39
Silver
North 2306, Briot's second
milled issue

The obverse of this coin has the legend "CAROLVS · D · G · MAG · BRIT · FR · ET · HIB · REX ·" and depicts the bust of Charles I, crowned and mantled. To the right is the value mark, *VI*. The reverse legend reads, "CHRISTO · AVSPICE · REGNO ·" (I reign under the auspice of Christ), and shows a square-topped shield over a cross moline.

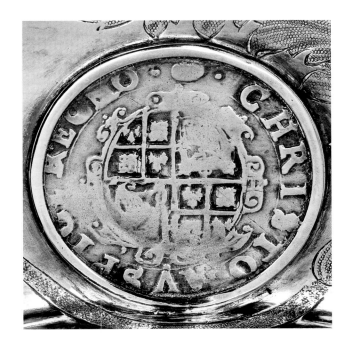

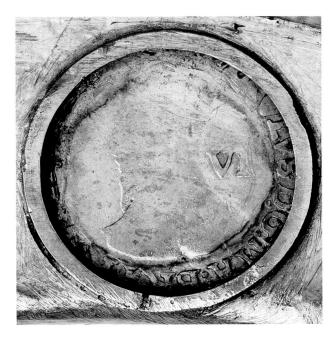

72

Sixpence of Charles I

Tower Mint, 1636–38

Silver

North 2241

This sixpence has evidence of die wear. The obverse (on the interior of the cup) is worn to such an extent that, were it not for the decipherable part of its legend and the reverse, it would be impossible to identify it as a coin of Charles I. Among the many treasures on the Naseby Cup, it is this kind of object—a worn-down, seemingly ordinary coin—that provides circumstantial evidence and support to the claim on the pedestal of the cup that "many of [the coins and medals] . . . have been dug up on the Scene of Action."

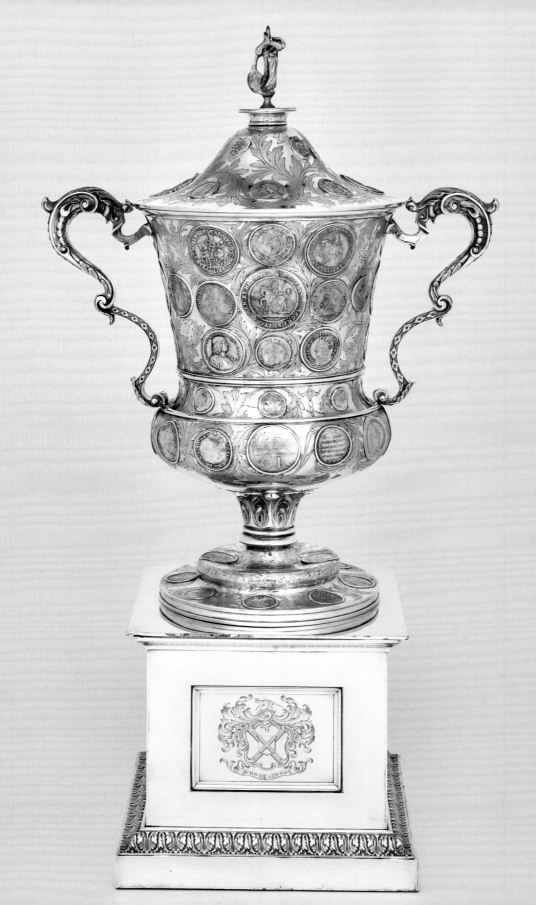

Notes

Chapter 1

1. Foard 1995, 343–44.

2. Droth, Edwards, and Hatt 2014, 16, 148.

3. One landowner of the Cockayne family built a small temple, or "alcove," in Rushton Hall, Northamptonshire, that had a view of Naseby field.

4. Foard 1995, 357–59. In a letter dated September 20, 1842, Edward Fitzgerald wrote that his "papa" was responsible for the obelisk; see Edward Fitzgerald, letter to W. F. Pollock, September 20, 1842, in Fitzgerald 1901, 133.

5. One example is the collection of the Ashby family, who purchased Naseby Wooleys from the Fitzgeralds in 1857. This collection was auctioned in 1888 following Captain George Ashby's bankruptcy. A report in the *Northampton Mercury* of February 11, 1888, commented on the unquestionable authenticity of the items and the precise record of where each item was found. After the objects were sold, however, their provenance appears to have been lost. Ashby changed his name numerous times: Captain Ashby Ashby, Captain George Ashby Maddock, and George Ashby Ashby; see Foard 1995, 383n16.

6. Foard 1995, 344–51; and (as cited in Foard 1995, 383n18) *Sale Catalogue of Naseby Woolleys* [sic], sale cat. (February 1888), NRL; see also *Northamptonshire Notes and Queries*, n.s., vol. 5 (1921–23), item 283; o.s., vol. 3 (1889), 48, 66–68.

7. Platt and Platt 2013, 2:97–101.

8. Foard 1995, 350.

9. The types are M.I.i. 317/150, Platt and Platt type A; and M.I.i. 318/151, Platt and Platt type B.

10. Foard 1995, 354–56; and Martin 1985, 67–69, 126–28.

11. Martin 1985, 22–44.

12. Mary inherited Naseby Wooleys as part of a significant portion of the estate of Jane Joyce, her great-aunt; see ibid., 26–27.

13. Ibid., 26–40.

14. Ibid., 25.

15. Ibid., 40–41.

16. Bellenir 2004, 33.

17. Dickens 1850, 297; and Goodrich 1846, 314.

18. Typically the visor of the helmet would be closed, but here it appears to be open.

19. Burke 1884, iv, 354.

20. Martin 1985, 32, 37–41.

Chapter 2

1. Given the intricacies of the events and the various participating sides, the English Civil War is considered a series of wars, not a single war. The singular term "English Civil War," however, is used to describe the overall conflict and turbulence of the period, which spread far beyond the British Isles.

2. Financial difficulties for the Crown were not a novelty. The monarchs preceding Charles I—Henry VIII, Elizabeth I, and James I—were all forced to sell property for income. It has been estimated that in 1629 the Crown could not expect to have an annual income greater than £10,000 through land revenues, a sum that a wealthy merchant could have earned; see Ashley 1990, 8.

3. Charles had been disgraced by an unsuccessful attempt to marry the sister of King Philip III of Spain (r. 1598–1621) while visiting Madrid. He also wanted to regain the German Palatinate, a region that England had lost and which Spain had partially taken over at the outbreak of the Thirty Years' War in Europe.

4. Charles only received one-seventh of the funds he required from taxation. In addition, the Commons only approved the allocation of the normal customs duties, known as "tonnage and poundage," for a single year rather than granting him the income of tonnage and poundage for the entirety of his reign, as was the norm.

5. Some of these taxes were not new, such as the revival of an Elizabethan tax known as "ship money." About £750,000 was raised

through the collection of this tax between 1637 and 1640; see Ashley 1990, 10.

6. Fletcher 1981, xxiii.

7. Ashley 1990, 1.

8. Fletcher 1981, 406–14 (quotation on p. 413). For a more detailed consideration of the causes of the Civil War, see Ashley 1990, 1–40.

9. Charles's ship-money levy would end, but "tonnage and poundage" could continue with Parliament's approval; see Fletcher 1981, 4–24.

10. Ibid., xix.

11. Charles I 1649.

12. Ashley 1990, 50–51; Ashley 1992, 1–17; and Platt and Platt 2013, 1:xxxi, 1–17. For a detailed narrative of the outbreak of the war, see Fletcher 1981.

13. Fletcher 1981, 415.

14. Platt and Platt 2013, 1:21.

15. It has been noted that Parliament held a position analogous to that of the Union in the American Civil War; see Platt and Platt 2013, 1:22.

16. Ibid., 1:32, 46; and Ashley 1992, 23–24.

17. Platt and Platt 2013, 1:60; and Ashley 1992, 24, 30–35.

18. For more on Charles's establishment of new mints during the war, see chapter 3 and figure 3.1 in the present volume. Charles also set up a Council of War, which convened at Christ Church College, Oxford University, and a counter-Parliament in the University Convocation House.

19. The confrontations were at Cropredy Bridge, Oxfordshire, on June 29, 1644; Marston Moor, Yorkshire, on July 2, 1644; and Newbury, Berkshire, on October 27, 1644.

20. Ashley 1992, 36–46.

21. Maurice Ashley provides a summary of the discussions between the House of Lords and the House of Commons; see ibid., 49.

22. Ibid., 49–53.

23. Ibid., 54–66; and Platt and Platt 2013, 1:60–72.

24. Sprigge (1647) 1995.

25. Foard 1995, 17–18; and Louth 2016, 144–45. The scale and idealized formations in Streeter's map require careful review to interpret.

26. Ashley 1992, 65–74; and Platt and Platt 2013, 1:72. See Ashley 1992, 154–56, for an in-depth discussion of various estimated figures. Glenn Foard goes into considerable detail to estimate army strength; see Foard 1995, 197–209. Despite the survival of maps with regimental lines at the battlefield, estimating the total size of the two armies is difficult, because the number of officers and men in each formation varied considerably. The numbers of the Parliamentarian side are more secure, since the New Model Army had few occasions to suffer losses after its formation in the spring of 1645.

27. Sprigge (1647) 1995, 38, cited in Platt and Platt 2013, 1:74.

28. Platt and Platt 2013, 1:72–74.

29. The day after the battle, the Speaker of the House of Commons reported that about eight hundred members of the Royalist army had been slain. To this, one can add those who were pursued off the battlefield and died of their wounds, a number that was not likely more than two hundred.

30. Ashley 1992, 67–91.

31. Hutton 1982, 63.

32. Ashley 1992, 101–5. Prince Rupert had assured Charles that he could hold Bristol for four months with his garrison of 1,500 men, but Fairfax, with 10,000 men, was able to storm the city, forcing Rupert to surrender. Fairfax's biographer, Clements Markham, believed that Rupert's surrender was politically motivated. While this may be possible, Rupert was also unaware of Charles's intention to relieve him. Charles later forgave Rupert at the Council of War.

33. Ashley 1992, 107–10.

34. Ibid., 111–15.

35. Ibid., 116–18.

36. Ashley 1990, 148–50.

37. Ibid., 151–63.

38. Ibid., 165–68.

39. Ibid., 169–77.

40. Ibid., 169–93. Parliament had placed a bounty of £1,000 on Charles II; see Hibbert 1993, 290. During his journey, Charles learned about the people's devotion to religion and their ancient loyalties, which would ultimately bring him to the throne.

41. Cromwell was rewarded with a London residence, rural lands, and a country residence, Hampton Court Palace—former home and then prison of Charles I. He also received the chancellorship of Oxford University.

42. Roots 1966, 164–70. The document included elements of a proposal that had been offered to Charles I after his defeat in the First Civil War. For more on the Instrument of Government and the power it granted Cromwell, see Roots 1966, 171–72, 181–89.

43. Platt and Platt 2013, 2:12–16; and Roots 1966, 172–80, 210–19.

44. Roots 1966, 232–79.

45. Platt and Platt 2013, 1:106–7; and Ashley 1990, 192.

Chapter 3

1. Besly 1990, 2. The reason lies in the adoption of a new and lower fineness.

2. Ibid., 91.

3. North 1991, 20–22.

4. Besly 1990, 11–12. There is a long and continuous debate about the accuracy of die estimates and their use for historical and numismatic inquiry; see Buttrey 1993; Buttrey 1994; and De Callataÿ 1995.

5. Most often, these complications pertained to the quality of the coin—either its aesthetic appearance or its metallic aspect (its weight or fineness).

6. Copper farthing tokens were also part of the monetary system but were restricted tender and not true coins; see Sutherland 1973, 170–71.

7. Besly 1987, 53.

8. One coin was taken for every twenty-seven pounds of gold coinage, two coins for every thirty pounds of silver.

9. Grierson 1975, 110; Besly 1990, 9; and Symonds 1910, 389. For more original documentation of Trials of the Pyx under Charles I at the Tower Mint, see Symonds 1910.

10. For an explanation of the change in the official start date of the new year, see page 19 in the present volume. "Negro head" is a problematic term that has traditionally been associated with the 1627 privy mark.

11. The silver came to England largely through Mary Tudor's marriage to King Philip of Spain and, during the reign of Elizabeth I, through trade and organized piracy; see Besly 1987, 54. Large deposits of silver were simultaneously discovered in Central Europe, in Tyrol, Erzgebirge, and Saxony (in present-day Germany, Austria, and Italy); see Besly 1990, 2. During the reign of James I, however, silver coin production was limited. Following an arrangement with the Spanish in 1642, there was an extraordinarily high output that lasted until 1647; see Besly 1987, 54–55.

12. Besly 1990, 2–3.

13. Farquhar 1914, 176; and Symonds 1913, 367. Compare Briot's annual pay of £50 to that of a New Model Army foot soldier (£12) or cavalry trooper (£36.5); see Firth 1902, 189.

14. Besly 1990, 12–15. For a detailed summary of Briot's and other engravers' activities during the English Civil War, see Farquhar 1914; and Symonds 1913. For Briot's work in Scotland, see Stewart 1955, 105–11.

15. Before Briot's arrival in England, a series of tests in France compared his proposed rotary mechanisms to traditional hammering methods. The report was published in 1617 and reprinted in 1902.

For the reprint, see Mazerolle 1902; for the English translation, see Sellwood 1986.

16. Besly 1984, 213–14.

17. Scher 1994, 14–16.

18. Platt and Platt 2013, 1:xvii.

19. Ibid., 1:xix–xx.

20. Although some of Briot's letters reference medal making, most of his work was with coin-like pieces, some of which were intended as patterns and others specially produced as largesse or counters; see Jones 1988, 143–46.

21. Vertue 1753.

22. Nathanson 1975, 10.

23. Royal Proclamation of April 15, 1645; see Prosser 1913, 369.

24. Symonds 1913, 372–73; and Nathanson 1975, 10–13.

25. Clipped coins have had their circumference edge "clipped" (or shaved) to remove some minuscule portion of the precious metal, while still being of sufficient weight to permit their circulation.

26. Since Ramage lacked proficiency with the technique, he was forced to increase the thickness of the coins.

27. Nathanson 1975, 14–18.

28. Ibid., 19–25.

29. Ibid., 26–27.

30. Sutherland 1973, 171.

31. Nathanson 1975, 31.

32. Forrer 1912, 42. The electrotypes were produced by Robert Ready from the 1644 Oxford crown now in the British Museum, London.

33. This assumes that the initial R on these tokens belongs to Rawlins and not Ramage; see Forrer 1912, 38–41.

34. Nathanson 1975, 31–35.

35. Besly 1987, 53; and Kent 1974.

36. Besly 1987, 53–54. One contributing factor to the limited presence of gold

in Britain was that English debts on the Continent were settled with gold coins, since they were less bulky to transport than silver. At the same time, the gold coins found in hoards from this period consist mainly of those struck by James I and Charles I (trailing off in the mid-1630s), which reflects gold coin production and general availability.

37. Ibid., 54–55; and Besly 2015.

Catalogue

1. Hawkins, Franks, and Grueber 1969, 482. For the locket, see Baldwin's Auctions, London, sale cat. 69 (May 3–4, 2011), lot 12.

2. Platt and Platt 2013, 1:288–91.

3. Besly 1990, 72.

4. Hawkins, Franks, and Grueber 1969, 354; and Platt and Platt 2013, 1:192–94.

5. The type is incredibly difficult to determine. Jerome J. Platt guesses it is type C or N because of the "better than average well-defined horizon"; Jerome J. Platt, email message to author, June 23, 2018.

6. M.I.i. 391; and Platt and Platt 2013, 1:311.

7. Hawkins, Franks, and Grueber 1969, 391.

8. There are likely fewer than five surviving original large Dunbar Medals. The larger medal was possibly intended for the rank and file, while the smaller was possibly for senior officers and other individuals. The distribution of larger (and thus more costly) medals to lower ranks may seem paradoxical; this remains speculation until corroborating documentation surfaces. Based on the number of surviving specimens, however, it seems that very few were ever issued.

9. Platt and Platt 2013, 1:316; and Vertue 1753, 13n.

10. Lilburne was captured at the Battle of Edgehill and released after six months. He received a reward of £300 from the Earl of Essex (see cat. 12) for his loyal conduct at his trial. For a riveting account of Lilburne's life, see Platt and Platt 2013, 2:203–8.

11. Jerome J. Platt, email message to author, June 23, 2018.

12. The attribution to Rawlins is based on the medal's similarity to well-preserved examples at the British Museum and the Hunterian Museum in London; see Platt and Platt 2013, 1:154.

13. In Hawkins, Franks, and Grueber 1969, 360, M.I.i. 360/231 is summarized by one entry with the clause "It also appears without a border." Platt and Platt treated this type separately; see Platt and Platt 2013, 1:173.

14. Above the portrait head, *S X* is an abbreviation for "Essex."

15. He had very clearly defined goals and reasons to side with Parliament, above all regarding the protection and advancement of the rights of Protestants and the king's subjects (including Parliament); see Platt and Platt 2013, 2:79–86.

16. John P. C. Kent described them as "meagre"; see Kent 1984, xxiv.

17. Platt and Platt 2013, 1:340.

18. A number of base-metal half crowns were once believed to have been an experimental issue of this coinage, but they have now been identified as forgeries that were possibly made toward the end of the eighteenth century (North 2312); see North 1991, 21.

19. For more on the products of the York mint, including a die study, see Besly 1984.

20. Besly 1990, 60–61.

21. The merk and half merk were Scottish denominations. The half merk was valued at about six shillings and eight pence Scots. On the half merk, the value is indicated behind the obverse bust, with the number *VI* over an 8.

22. Murray 1970, 123–24.

23. The portrait in catalogue number 14 is classified as "bust 5," while that in catalogue number 22 is classified as "bust 5a"; see Brooker, nos. 84 and 97, respectively. For more on the portraits, see Osborne 1984.

24. Brooker, no. 863a.

25. Murray 1970, 125.

26. Platt and Platt 2013, 2:25–27; and Hawkins, Franks, and Grueber 1969, 434–35.

27. Platt and Platt 2013, 2:25–27; and Hawkins, Franks, and Grueber 1969, 434–35.

28. Murray 1970, 126.

29. Jones 1988, 250–52.

30. The obverse legend slightly differs by type, as does the inclusion of lozenges.

31. Platt and Platt 2013, 1:133–34.

32. Ibid., 1:260–63.

33. Murray 1970, 114.

34. Ibid., 118.

35. The groat, threepence, and twopence are known to exist.

36. Besly 1990, 84–87. No proper or systematic study of Ormond money exists; most references only list the denominations or some of the many variations.

37. Platt and Platt 2013, 1:128–29.

38. The sets cost six guineas in bronze and fifteen guineas in silver.

39. The second type (B) was made from the original dies. The medals of this type show die wear, and occasionally the *I* in the year on the reverse is substituted by the letter *J*.

40. Boon 1984, xxxvii.

41. See Crow 1974.

42. Usually the General Court of Massachusetts took great care to avoid trouble with England; see Akin, Bard, and Akin 2016, 53.

43. At least five other Massachusetts silver coins have been recorded in Britain by the Portable Antiquities Scheme, although their date of arrival is unknown; see Crosby 1974, 70–71, 104–5.

44. Hellings 2018.

45. For a similar die (probable reverse die link), see Spink, London, auction 17006, sale cat. (September 25, 2017), lot 823.

46. Besly 1990, 77–78.

47. Brooker, no. 571.

48. North 1991, 141–46.

Bibliography

Akin, Bard, and Akin 2016. Akin, Marjorie H., James C. Bard, and Kevin Akin. *Numismatic Archaeology of North America: A Field Guide.* New York: Routledge, 2016.

Ashley 1990. Ashley, Maurice. *The English Civil War.* Revised and re-illustrated edition. Gloucester, England: Sutton, 1990.

Ashley 1992. Ashley, Maurice. *The Battle of Naseby and the Fall of King Charles I.* New York: St. Martin's, 1992.

Bellenir 2004. Bellenir, Karen. *Religious Holidays and Calendars: An Encyclopedic Handbook.* 3rd ed. Detroit: Omnigraphics, 2004.

Besly 1984. Besly, Edward. "The York Mint of Charles I." *British Numismatic Journal* 54 (1984): 210–41.

Besly 1987. Besly, Edward. *English Civil War Coin Hoards.* British Museum Occasional Papers 51. London: British Museum, 1987.

Besly 1990. Besly, Edward. *Coins and Medals of the English Civil War.* London: Seaby, 1990.

Besly 2015. Besly, Edward. "Mapping Conflict: Coin Hoards of the English Civil War." In *Hoarding and the Deposition of Metalwork from the Bronze Age to the 20th Century: A British Perspective*, ed. John Naylor and Roger Bland, 181–200. Oxford: Archaeopress, 2015.

Boon 1984. Boon, George C. "Provincial and Civil War Issues." In Brooker, xxix–xlvi.

Brooker. North, Jeffrey J., and Peter J. Preston-Morley, eds. *The John G. Brooker Collection: Coins of Charles I (1625–1649).* Sylloge of Coins of the British Isles 33. London: Spink and Son, 1984.

Burke 1884. Burke, Bernard. *The General Armory of England, Scotland, Ireland, and Wales: Comprising a Registry of Armorial Bearings from the Earliest to the Present Time.* London: Harrison and Sons, 1884.

Buttrey 1993. Buttrey, Theodore V. "Calculating Ancient Coin Production: Facts and Fantasies." *Numismatic Chronicle* 153 (1993): 335–51.

Buttrey 1994. Buttrey, Theodore V. "Calculating Ancient Coin Production II: Why It Cannot Be Done." *Numismatic Chronicle* 154 (1994): 341–52.

Charles I 1649. Charles I. Εἰκὼν Βασιλική: *The Pourtraicture of His Sacred Majestie in His Solitudes and Sufferings.* London: n.p., 1649.

Crosby 1974. Crosby, Sylvester S. *The Coins of Early America.* Lawrence, Mass.: Quarterman, 1974.

Crow 1974. Crow, Steven Douglas. "'Left at *Libertie*': The Effects of the English Civil War and Interregnum on the American Colonies, 1640–1660." PH.D. diss., University of Wisconsin, 1974.

De Callataÿ 1995. De Callataÿ, François. "Calculating Ancient Coin Production: Seeking a Balance." *Numismatic Chronicle* 155 (1995): 289–311.

Dickens 1850. Dickens, Charles. "Earth's Harvests." *Household Words: A Weekly Journal* 1, no. 13 (June 22, 1850): 297.

Droth, Edwards, and Hatt 2014. Droth, Martina, Jason Edwards, and Michael Hatt, eds. *Sculpture Victorious: Art in an Age of Invention, 1837–1901.* Exh. cat. New Haven, Conn.: Yale Center for British Art, 2014.

Farquhar 1914. Farquhar, Helen. "Nicholas Briot and the Civil War." *Numismatic Chronicle* 14 (1914): 169–235.

Firth 1902. Firth, Charles H. *Cromwell's Army: A History of the English Soldier during the Civil Wars, the Commonwealth, and the Protectorate.* London: Methuen, 1902.

Fitzgerald 1901. Fitzgerald, Edward. *Letters of Edward Fitzgerald.* London: Macmillan, 1901.

Fletcher 1981. Fletcher, Anthony. *The Outbreak of the English Civil War.* New York: New York University Press, 1981.

Foard 1995. Foard, Glenn. *Naseby: The Decisive Campaign*. Whitstable, England: Pryor, 1995.

Forrer 1912. Forrer, Leonard. *Biographical Dictionary of Medallists, Coin-, Gem-, and Seal-Engravers, Mint-Masters, &c., Ancient and Modern, with References to Their Works.* Vol. 5. London: Spink and Son, 1912.

Goodrich 1846. Goodrich, Samuel G. *A Pictorial History of England*. Philadelphia: Sorin and Ball, and Samuel Agnew, 1846.

Grierson 1975. Grierson, Philip. *Numismatics*. London: Oxford University Press, 1975.

Hawkins, Franks, and Grueber 1969. Hawkins, Edward, Augustus W. Franks, and Herbert A. Grueber. *Medallic Illustrations of the History of Great Britain and Ireland to the Death of George II*. Vol. 1. Reprint, London: Spink and Son, 1969.

Hellings 2018. Hellings, Benjamin D. R. "(Re-)Discovery: Yale's Second and Third Noe II-A New England Shillings." *Journal of Early American Numismatics* 1, no. 1 (2018): 67–73.

Hibbert 1993. Hibbert, Christopher. *Cavaliers and Roundheads: The English at War, 1642–1649*. London: HarperCollins, 1993.

Hutton 1982. Hutton, Ronald. "The Royalist War Effort." In *Reactions to the English Civil War, 1642–1649*, ed. John S. Morrill, 51–66. London: Macmillan, 1982.

Jones 1988. Jones, Mark. *A Catalogue of the French Medals in the British Museum*. Vol. 2, *1600–1672*. London: British Museum, 1988.

Kent 1974. Kent, John P. C. "Interpreting Coin Finds." In *Coins and the Archaeologist*, ed. John Casey and Richard Reece, 184–200. London: Institute of Archaeology, 1974.

Kent 1984. Kent, John P. C. "Coinage at the Tower Mint." In *Brooker*, xxi–xxvii.

Louth 2016. Louth, Warwick. "Organised Chaos: Applying Seventeenth-Century Military Manuals to Conflict Archaeology." In *New Approaches to the Military History of the English Civil War: Proceedings of the First Helion and Company "Century of the Soldier" Conference*, ed. Ismini Pells, 115–50. Solihull, England: Helion, 2016.

Martin 1985. Martin, Robert B. *With Friends Possessed: A Life of Edward Fitzgerald*. London: Faber and Faber, 1985.

Mazerolle 1902. Mazerolle, Fernand. *Les médailleurs français du XVe siècle au milieu du XVlle*. Paris: Imprimerie nationale, 1902.

Murray 1970. Murray, John K. R. "The Scottish Gold and Silver Coinages of Charles I." *British Numismatic Journal* 39 (1970): 111–44.

Nathanson 1975. Nathanson, Alan J. *Thomas Simon: His Life and Work, 1618–1665*. London: Seaby, 1975.

Noe 1973. Noe, Sydney P. *The Silver Coinage of Massachusetts*. Lawrence, Mass.: Quarterman, 1973.

North 1991. North, Jeffrey J. *English Hammered Coinage*. Vol. 2, *Edward I to Charles II, 1272–1662*. London: Spink and Son, 1991.

Osborne 1984. Osborne, Bernard R. "The Tower Coins of Charles I." *British Numismatic Journal* 54 (1984): 164–209.

Platt and Platt 2013. Platt, Jerome J., and Arleen K. Platt. *The English Civil Wars: Medals, Historical Commentary, and Personalities*. 2 vols. London: Spink and Son, 2013.

Prosser 1913. Prosser, R. B. "English Mint Engravers of the Tudor and Stuart Periods, 1485 to 1688." *Numismatic Chronicle* 13 (1913): 349–88.

Roots 1966. Roots, Ivan. *Commonwealth and Protectorate: The English Civil War and Its Aftermath*. Westport, Conn.: Greenwood, 1966.

Scher 1994. Scher, Stephen K. *The Currency of Fame: Portrait Medals of the Renaissance*. New York: Harry N. Abrams, 1994.

Sellwood 1986. Sellwood, David. "The Trial of Nicholas Briot." *British Numismatic Journal* 56 (1986): 108–23.

Sprigge (1647) 1995. Sprigge, Joshua. *Anglia Rediviva; England's Recovery: Being the History of the Motions, Actions, and Successes of the Army under the Immediate Conduct of His Excellency Sr. Thomas Fairfax, Kt. Captain-General of all the Parliament's Forces in England*. Reprint, London: Cromwell Productions, 1995. First published 1647.

Stewart 1955. Stewart, Ian H. *The Scottish Coinage*. London: Spink and Son, 1955.

Sutherland 1973. Sutherland, Carol H. V. *English Coinage, 600–1900*. London: B. T. Batsford, 1973.

Symonds 1910. Symonds, Henry. "Charles I: The Trials of the Pyx, the Mint-Marks and the Mint Accounts." *Numismatic Chronicle* 10 (1910): 388–97.

Symonds 1913. Symonds, Henry. "English Mint Engravers of the Tudor and Stuart Periods, 1485 to 1688." *Numismatic Chronicle* 13 (1913): 349–77.

Vertue 1753. Vertue, George. *Medals, Coins, Great-Seals, Impressions, from the Elaborate Works of Thomas Simon, Chief Engraver of the Mint to K. Charles the 1st to the Commonwealth, the Lord Protector Cromwell, and in the Reign of K. Charles Ye IId to MDCLXV*. London: G. Vertue, 1753.

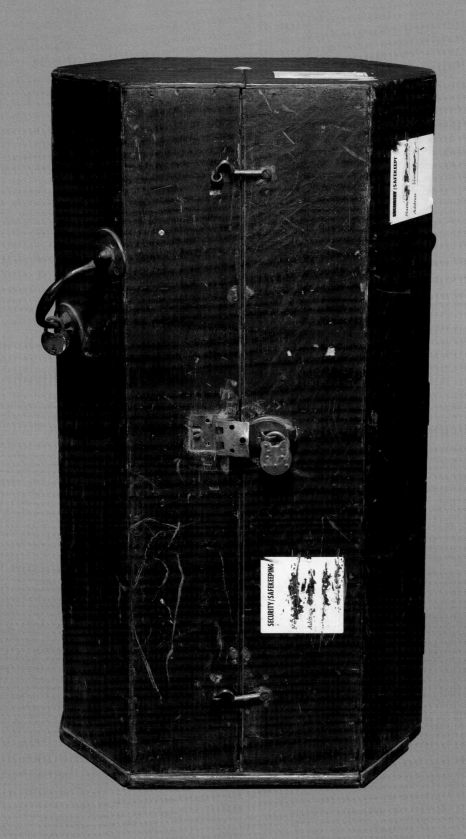

Photo Credits

Every effort has been made to credit the artists and the sources; if there are errors or omissions, please contact the Yale University Art Gallery so that corrections can be made in any subsequent editions. All images courtesy Visual Resources Department, Yale University Art Gallery, unless otherwise noted.

Adrian Kitzinger: fig. 3.1; pp. 58–59

© Ashmolean Museum, University of Oxford: fig. 3.7

Photo: Benjamin D. R. Hellings: p. 6; figs. 1.1, 2.8

Photo: © Bodleian Libraries, University of Oxford: fig. 2.6

From: Robert B. Martin, *With Friends Possessed: A Life of Edward Fitzgerald* (London: Faber and Faber, 1985): fig. 1.6

Image courtesy of the National Army Museum, London: fig. 2.7

© The National Gallery, London: p. 24

© National Portrait Gallery, London: figs. 2.2, 2.9

Royal Collection Trust/© His Majesty King Charles III 2024: fig. 2.1

Royal Mint Museum/Bridgeman Images: fig. 3.2

Reproduced by kind permission of the Syndics of Cambridge University Library: fig. 1.4

© The Trustees of the British Museum: figs. 1.2–.3, 1.5, 3.3, 3.6